Zhang Xiaogang 张晓刚

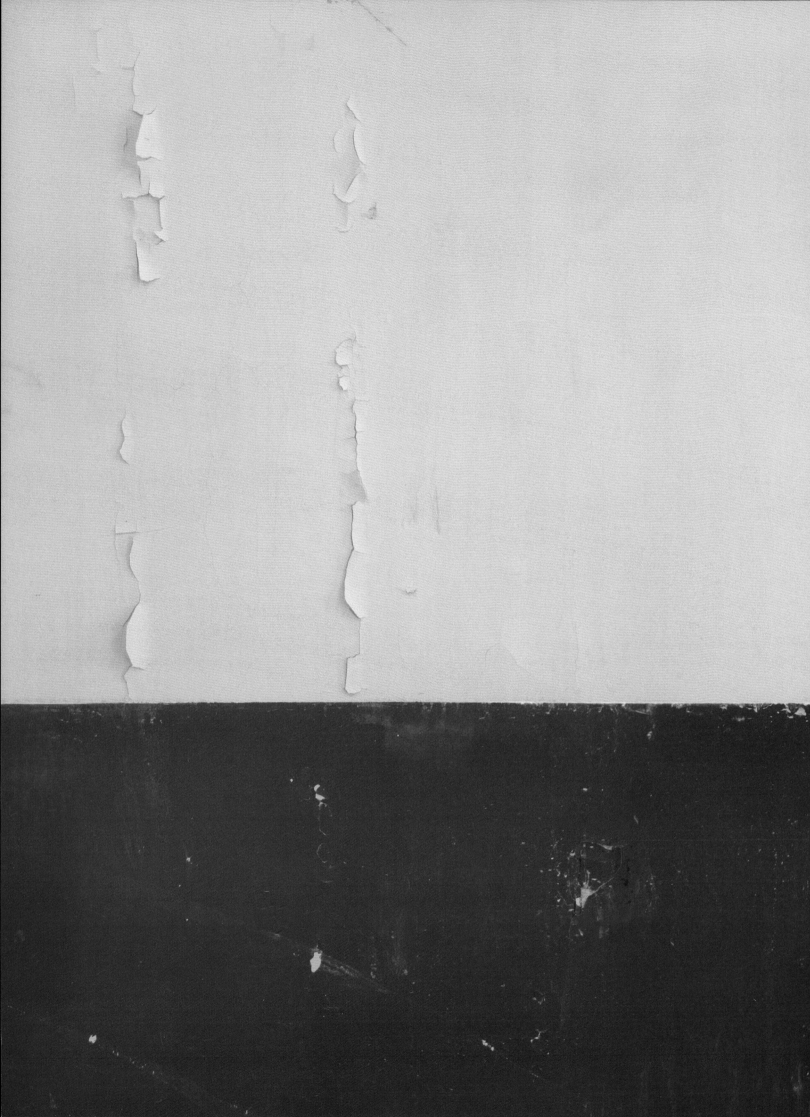

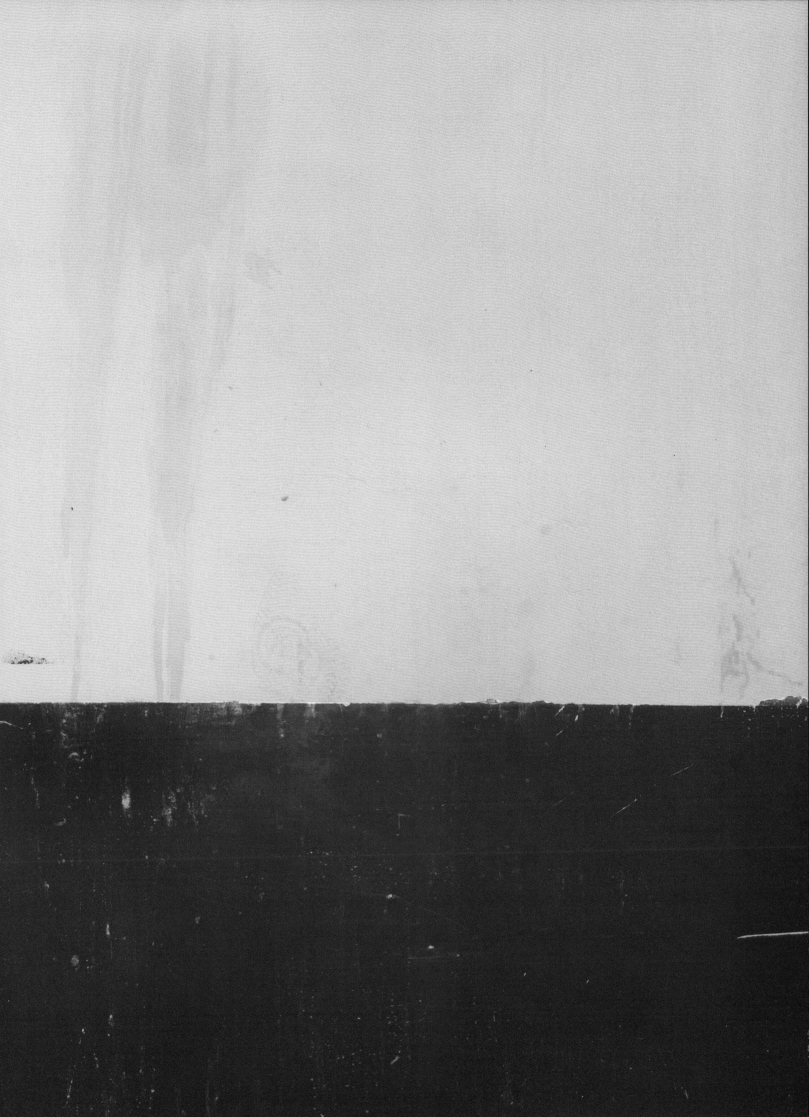

REVISION

OCTOBER 31 - NOVEMBER 29, 2008 2008年10月31日－11月29日

PACEWILDENSTEIN 佩斯维尔登斯坦

534 WEST 25TH STREET NYC 纽约西25街534号

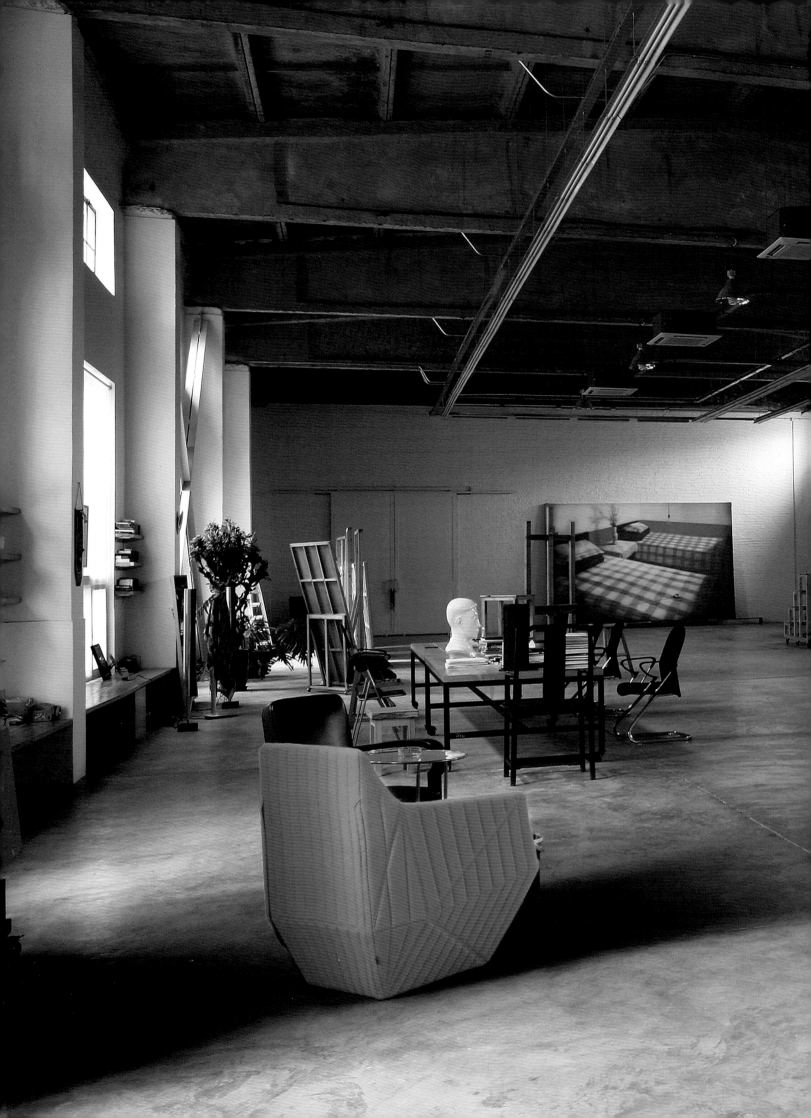

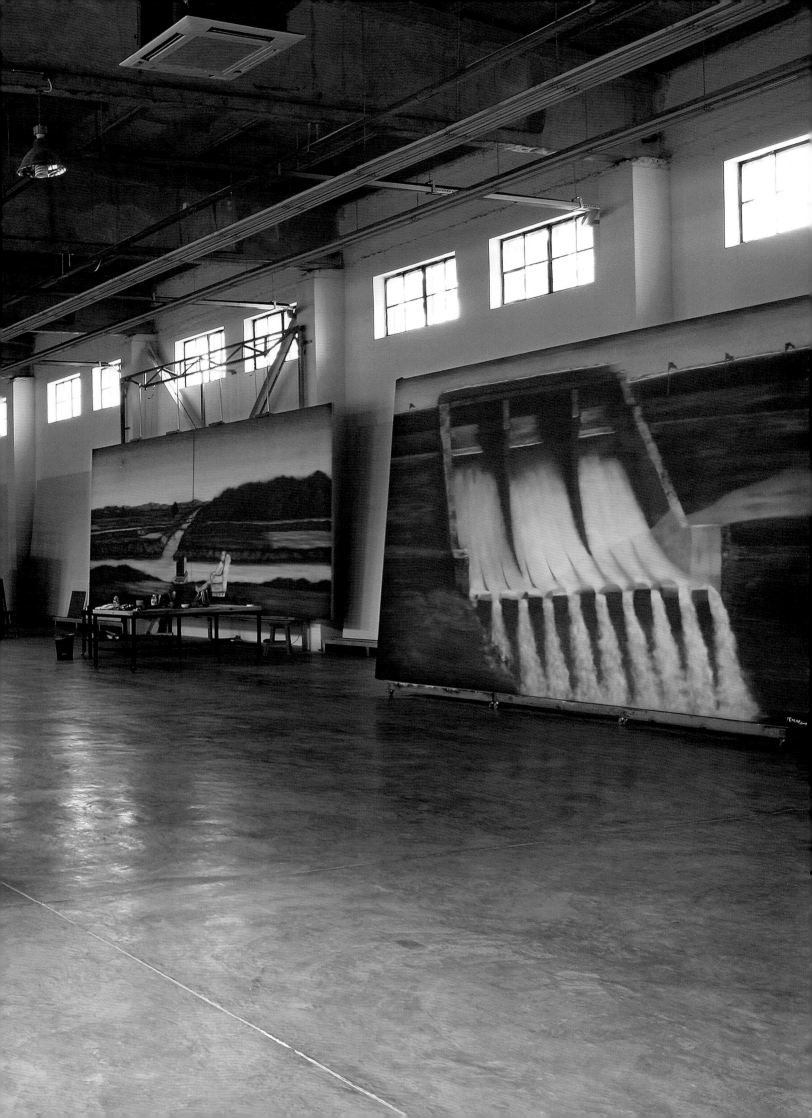

Preface
前 言

Preface

Arne Glimcher

The early 1990s witnessed the emergence of a revitalized Chinese contemporary art world. As with all such historical moments, it began as a reaction against the existing Social Realistic style which conveyed government approval. Zhang Xiaogang was amongst the first group of artists to establish a style that embodied this break and was categorized as Cynical Realism. It illuminated the break with Social Realism, a term used by authoritarian regimes to describe the political purpose for artistic styles in the service of social betterment. Now, fifteen years later, the artist's aspiration to create a personal vision has long since subsumed his desire to make a political statement. Indeed, Zhang Xiaogang's works are anything but cynical. To the contrary, the work's metaphysical nature displays the innocence of Proust's *Remembrance of Things Past*, with all its pain of loss and relief of recovery. It conveys an urgent narrative of his life before the world as he knew it, was destroyed by the Cultural Revolution. In an obsessive, monumental recreation of time past, his famous "*Bloodline*" series, service as a collective family album posed like photographs in truncated space, he memorializes previous existence.

Some paintings have blotches of color on mostly monochromatic frozen images that are reminiscent of the long exposures of early photography. The blotchy imperfections humanize the paintings as if food specks or tea stains reclaim a living history greater than the isolated image. The awkward red "bloodlines" bring to mind cracks in the emulsion of photographs as if these family photographs were stuffed in a pocket to be viewed secretly again and again.

Formally they also recall the portrait paintings on silk of dynastic emperors and dignitaries in which the minimum use of detail captures the essential elements of identity. But instead of individualistic imagery Zhang Xiaogang's portraits are collective metaphors mirroring the society in which they were created.

But why are these essentially Chinese paintings presented in western style? They are reminiscent of the early black and white airbrush portraits of Chuck Close, both in their scale and frontality, and the photo-derived paintings of Gerhard Richter where the brushwork has been blended into an anonymous surface. Indeed, Zhang Xiaogang visited Germany and met Richter.

Zhang Xiaogang's long-time friend and dealer, Leng Lin described that when the doors to the west opened the entire history of western art was revealed as one heroic adventure from the Renaissance to the present. It was not analyzed episodically, but rather the multiplicity of found styles influenced Chinese artists. Style was selected and employed in the service of a greater Chinese narrative. It was not unlike Picasso and Braque looking across the chasm of time and space at African sculpture and responding to its stylistic elements rather than to its societal function. Although they may have recognized its inherent magic, it didn't possess the utility as did the structural form for the invention of so analytical an art as Cubism.

In a counter response the Chinese were not responding to the legacy of Modernism, they were creating a narrative art uninfluenced by Modernist theory. Zhang Xiaogang adopts western style to convey an eastern narrative, and in doing so, he opens the door to a global artistic universe where style (like African sculpture for the Cubists) is interchangeable but the message remains endemic and unique to each culture.

前 言
阿尼·格林顺

中国当代艺术领域在上世纪九十年代早期经历了一场复苏。正如所有具有历史性意义的时刻一样，它首先表现为对官方认可的"社会主义现实主义"艺术风格的颠覆。张晓刚是最早树立这种颠覆性艺术风格的画家之一。这种风格在当时被称为"玩世现实主义"，它表明了与"社会主义现实主义"的决裂。集权政府用"社会主义现实主义"这一术语来强调艺术风格服务于社会改造的政治目的。现在，十五年过去了，张晓刚对个人艺术风格的探索一直都包含着对表达政治态度的渴望。事实上他的作品和"玩世"毫无关联。相反，作品的空玄入微显现出普鲁斯特《追忆似水年华》的纯真，蕴含着"无可奈何花落去"的伤楚和"似曾相识燕归来"的释怀。作品中透露出艺术家表述文革之前生活的渴望，而那个世界在文革当中毁于一旦。他著名的《血缘》系列反复痴迷地重现着往日岁月，俨然一部家族相簿，作品仿佛是一张张照片，张贴在时空的层层断面之上，艺术家在此纪念着往昔的存在。

其中某些作品几近单色的冰冷形象上斑痕点点，让人回想起老照片经时间洗礼后的斑驳之感。不过画面上的斑痕使作品看上去更加人性化，类似食物霉斑或茶渍的痕迹，似乎比单一的肖像更能还原那段真实的历史。稚拙的红色"血线"让人想起照片表面的裂痕，就好像这些家庭照片曾塞在口袋里被偷偷地反复拿出来观看。

在形式上，这些作品也使我们想起了中国古代帝王或权贵的绢本肖像画，其中人物特征的细节被削减，仅仅捕捉最能反映身份的元素。但张晓刚的肖像作品不同于个体肖像，它是一种集体的隐喻，映照着其身所处的社会。

可是本质上是中国的艺术，为什么却要采用西方的艺术风格来呈现？无论在尺度上，还是正面描绘肖像的方式上，这些作品都让我们想起查克·克洛斯（Chuck Close）的黑白喷绘肖像，以及格哈德·里希特（Gerhard Richter）那些源自照片、画面笔触完全隐去的作品。事实上，张晓刚访问过德国并见过里希特。

张晓刚多年的好友兼经纪人冷林曾说："当通向西方的大门被打开，从文艺复兴到现代的整个西方美术史，就像一场英雄主义历险一样一一呈现出来。"西方艺术史并没有被系统地分析和接受，中国艺术家们未加区别地同时接受了各个时代的西方艺术的影响。艺术家选取和运用某种西方风格以进行更宏大的中国式叙事，正如毕加索和布拉克跨越时空的鸿沟，对非洲传统雕塑艺术中的风格元素而非其政治功能做出了反响。虽然他们也感知到了非洲雕塑的内在魅力，但是就创造立体主义这一高度分析性的艺术风格而言，这种魅力远没有其造型的结构性更有价值。

与之相反的是，中国当代艺术家并没有直接对现代主义的遗产做出响应，他们创造了一种未受现代主义理论影响的叙事艺术。张晓刚采用西方风格来传达一种东方式的叙事，从而打开了通向世界艺术平台的大门。在这里，艺术风格可以互换（就像非洲雕塑对于立体派而言），但作品中传递的信息却始终保留着不同文化的地域性和独特性。

Zhang Xiaogang's New York Exhibition

为张晓刚纽约展而写

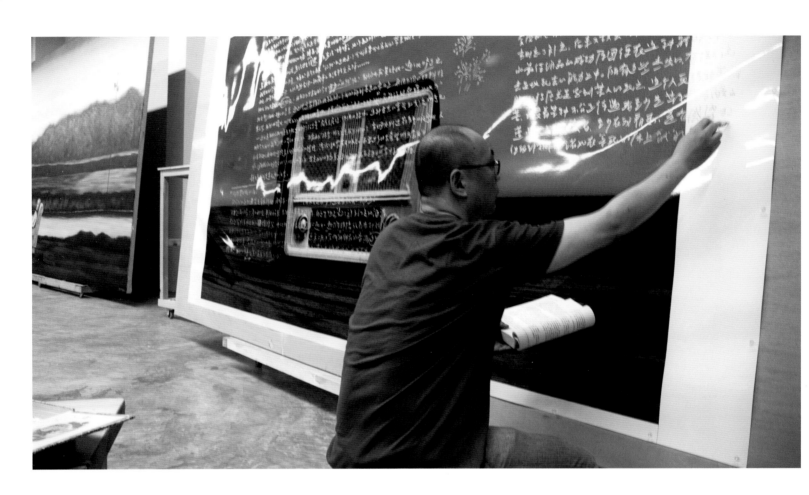

2008, working in Beijing studio　2008年，于北京工作室创作中

Zhang Xiaogang's New York Exhibition
Leng Lin

In today's art world, Zhang Xiaogang seems like a relatively conservative artist. He insists on painting having a narrative and believes in painting's contemporary power. He strives to bring an art historical dimension to each of his works. Zhang's artworks focus on the relationship with past, memory and history. The artist has always placed an emphasis on the existence of history and memory in the present. In his works, history exists in the present, there is no way to erase it, and it is continuously being revised. It is impossible to not involve history, our current perception is too derived from our memories. Zhang has always been a traditional artist, who expresses man's experiences and emotions through his paintings. Those scintillating spots, scars and lines on his canvases reveal the references to history and the release of emotions. Such traditional expression and the insistence on it brings us back to the belief in and worship of painting's narrative. His effort is to re-emphasize the power of emotion and feeling over the "super-flat" and "cool."

The vestiges of history in both memory and soul and various connections between past and present continuously appear in Zhang's series of the past decade or more: the birthmark-like scars and bloodlines in the *Bloodline: Big Family* series, the luminous facial spots and tear marks in the *Amnesia and Memory* series, and the electric cables, lamp cords, and pen and ink in the *In-Out* series. The paintings is this exhibition, *Green Wall* series, include familiar imagery from the past: the bloodlines represent connection and the light spots express hope and confidence, specifically. These works couple artistic mining with reflection on the importance of history and stories both personally and publicly.

In China, green was the other revolutionary color besides red. It is plain, natural and commonplace, and was the fashionable color in 1960s and 70s China. Every young person wanted to wear the green military uniform and hat. By employing this green, the artist attempts to locate the intermingling of the individual and the collective. This pairing is both sensible and orderly. In one of Zhang's journal entries, he wrote:

Perhaps this is an era where sensibility and order need to live in mutual co-existence. Perhaps we need to acquire some sort of ambiguous descriptive mode in order to confront our rapidly transforming era? Perhaps we should try harder to forget, try to be in a state of amnesia where we may overcome many embarrassing realities.

The military coat in *Green Wall - Military Uniform* was once everybody's desired object, so much so that it seems as if it still contains the warmth of their hopes. The silence of the scenery in *Green Wall - Wooden Bench* hints at remembrance and questions what came before – has someone just left the bench, what memories remain? References to existence and emotional residue previously appeared in the *Amnesia and Memory* series. In that case, the dreamlike portrait explored the expression of emotions. In this new series of works, the references to issues of existence and memory occur in more open spaces. We can also see the artist reexamine history. In the 1960s and 70s in China, a common yet distinctive practice was to paint the bottom portion of the wall green. This was done in private spaces such as homes and in public environments like hospitals, schools, and government offices. In the spirit of collectivism, the differentiation between private and public did not exist. The artist uses the green wall to obscure the boundary between private and public spaces, and people's psychological status in such a non-segregated space also becomes complicated and ambiguous. *Green Wall - Wooden Bench* emphasizes the divided space. The table-cloth covered coffee table and the radio to belong to a private

family space, however, the long wooden bench suggest a public space. In a more dramatic display, *Green Wall - Reader* demonstrates the complexity and subtlety of an individual's psychological activities in a borderless space. A nude figure is reading (a solitary activity) in a (green-walled) space that is hard to determine whether it is public or private. Is this a portrayal of people's spiritual experience of the time? And the appearance of a modern camera suggests a present viewpoint. The contemporary quality in Zhang's works is this repeateded observance of past and history, and unceasing revision of the present through "amnesia" and memory.

In truth, the artist's interest in blurred boundaries - where the separation between collective and individual and private and public in certain time periods becomes unclear - has been apparent since the early *Bloodline: Big Family* series. Family is neither individualistic nor collective; it is a relationship or joint that connects an individual and the collective. Zhang has always recognized the past and present through familial relationships and patterns. *Green Wall - Landscape and Television* pairs imagery that is both contradictory in time and setting in a dramatic landscape. In recent years the artist has frequently utilized the loudspeaker and television to represent the public and private. The loudspeaker was the most common channel for broadcasting information to the people during the 1960s and 1970s in China. Everything from important announcements or government propaganda to trivial matters such as calling for an individual in a team or group, was announced in a public manner. In other words, people's knowledge of the outside world was realized through a collectivistic, non-private manner at that time. It was not until television, which did not appear in private spaces such as living rooms and become popular until after the reform and open policy of the 80s, that people's method of acquiring information became more intimate and optional. Both methods of digesting information and better understanding the world are experiences of Zhang's generation. The generation which experienced the Cultural Revolution as well as witnessed all the changes leading up to the present day. Zhang juxtaposes the two sceneries – in the background an electric post with a mounted loudspeaker stands in a vast, rural landscape and in the foreground a man seated on a sofa watching television as if at home. Zhang Xiaogang combines views from different times, so as to suggest that the broad landscape, which represents the socialist and collectivist viewpoint of the world, is still affecting his generation.

Zhang is an intellectual artist. The same intellectual mode of thought and spiritual experience present in his paintings are demonstrated in the traced narrative texts of his large-scale photographs. In his photographs in this exhibition, he has created an interior and exterior, both of which have a socialist Utopian feel to them. On the surface of these photographs, the artist records his ideas and thoughts in a journal-like manner. The images are taken from old films. Are these images depicting the background of Zhang's thoughts and experiences? Is the non-corresponding relationship between these images and languages suggesting that both history and memory add another dimension to the existing world today?

From the pictorial level, we can establish a certain connection between Chuck Close, Gerhard Richter and Zhang Xiaogang, which enriches the depth of the world of imagery. Close's paintings are a logical, material and physical analysis of portraits; Richter's paintings are a philosophy of images; while Zhang's paintings are about the historic issues of human kind. Whether it is *Bloodline: Big Family*, *In-Out*, or *Green Wall* series, Zhang continues to emphasize a sense of history. In his paintings, such relentless observation of history and experience are constantly being revised through memory. Revision is his persistent attempt to search for direction.

The word revision leads us to revisionism, which is a reaction or dilution of the pure, doctrine Communism that dominated the 1960s. In its most damning sense, to be a revisionist was equated to following a more capitalist agenda. To revisit revionism here is to add a new interpretation and understanding of the present world in the form of history. And Zhang's artworks obtain such purpose.

Despite the fact that this period of history and its experience was a regional one, the collectivistic, Utopian spirit at its base aimed to liberate man in the spirit of cosmopolitism. In his artworks, Zhang continuously links the present with this portion of the past through memory and reexamination. The serene face with the luminous spots and tears in *Green Wall - Slumber No. 2* questions whether the Utopian spirit is dead or temporarily asleep? These are not merely passing thoughts, this is an artist questioning his place in the world. I again would like to use one of Zhang's journal entries to clarify our current place and problem:

I indeed vividly "felt" it, we have really entered the globalized economic super highway. We have flown-over bridges from the "socialist avenue", and kept circling and spinning around and around above the multi-level bridges. From elementary school, high school, college, till now, there has all along been a voice echoing: "We are now facing a brand new era!" Yes, we are forever moving toward a new way of life, which implies you should abandon whatever you are now thinking with out any hesitation, leave the game that you have just become familiar with, so as to unfold the wings of imagination, with the sun beaming we quickly fly up high.

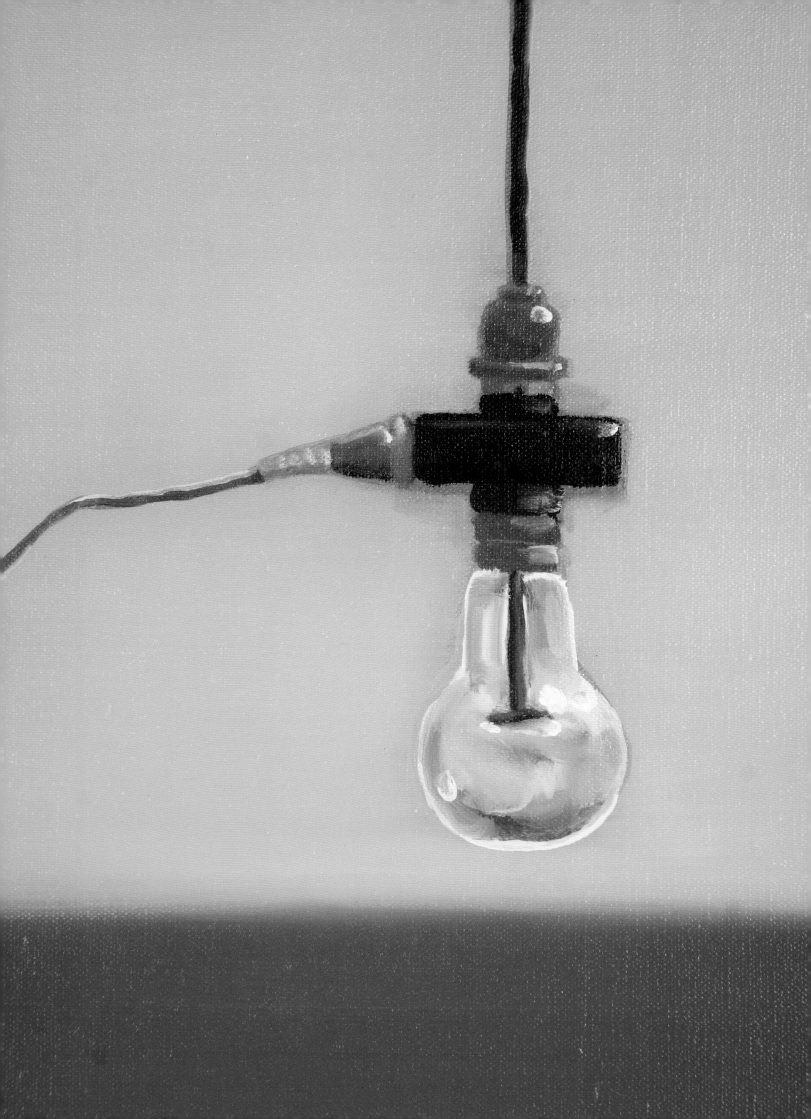

为张晓刚纽约展而写

冷 林

在当今世界艺术舞台上，艺术家张晓刚看起来更象是一位相对"保守"的艺术家，他坚持着绘画的叙述性，相信绘画的力量，并固执地把艺术的历史维度持续性地带到今天的艺术舞台上。与"过去"、"记忆"和"历史"持久、偏执的联系是张晓刚艺术的一个巨大特征。艺术家一直在通过他的艺术强调历史与记忆在当下的存在。在他的艺术中，"历史"就存在于现在，无法被抹去，并在今天不断的回忆中被不停地修正。今天无法抛弃与历史的纠结，而今天存在的深度正来自于历史在当下记忆中的痕迹。张晓刚一直是一位原始的、在绘画中表达着人的经验、故事与情感的艺术家。在他的绘画里，历史的维度、可感的温度和内心的情绪一直流露于画面上闪烁的斑痕与线条之中，这种原始的表达和对它的固守把我们重新带回到对绘画的叙述性的信仰和崇拜当中。这是一种在绘画中对"人"的重塑；在"超平"和"酷"年代里重建"人"的力量。

这种历史在记忆和心灵中产生的痕迹以及历史与当下的种种联系十几年来持续性地出现在张晓刚的不同系列的作品里：《大家庭》系列中类似胎记的斑痕和血线，《失忆与记忆》系列中投在面部的光斑和眼底的泪痕，以及《里和外》系列中的电线、灯绳、墨水和笔，都是在不断地强调这种痕迹与联系。此次展览的主体——《绿墙》系列的画面中除了依然有代表着联系的线与代表希望和对未来信心的光之外，我们也更强烈地触摸到（故事、历史）存在的痕迹和由此在人心中升起的温暖。

在中国"绿色"是区别于"红色"的另外一种革命的颜色，她朴素、自然和普遍，是中国60、70年代的流行色。当时，每一个年轻人都希望能穿上绿色的军衣、带上绿色的军帽。艺术家通过《绿墙》系列用"绿色"去重新寻找集体、个人的混合体。这个混合体同时也是感性和秩序的混合体。张晓刚在他的一篇日记中这样写到：

"这也许是一个感性和秩序需要同居的时代。也许我们需要学会某种暧昧的描述方式，以此来面对我们所面临的快速变化的时代？也许我们应该更多的学会忘却，在失忆的状态中跨越一个个令人尴尬的现实。"

《军大衣》中的军大衣是每个人曾经的希望之物，它似乎还带着人的希望的体温，《长椅》中静谧的场景似乎还暗示着前一刻的发生，是否刚刚有人离开？这种存在的痕迹和人的温暖感曾经在《失忆与记忆》系列梦幻般的肖像上表现为个人内在情绪的表达，而在这组作品里，对于存在与记忆的描述转换为更为开放的空间中的种种痕迹，我们也从中看到了艺术家重新审视历史的新视角。绿色的油漆墙围在中国的特殊历史时期中十分普遍，既存在于家庭这样的私人空间，也存在于医院、学校、政府机关等公共场所。在集体主义的精神氛围中，私人性与公共性的区分甚至对立并不存在。艺术家故意用绿墙模糊了私人空间和公共空间的边界，而人在无边界的空间中的心理痕迹也变得复杂且边界模糊。《长椅》正凸显了这种空间的无分界，盖着桌布的茶几和上面的收音机看似是属于家庭私人空间中的场景，而木条长椅又是公共场所的摆设。《读书者》更戏剧性呈现了个人的心理活动在无边界的空间中的复杂和微妙：一个赤裸的人在一个无法判断其公共与私密与否的（绿墙）空间里阅读（个人的心灵活动），这是否就是生活在那个时期的人们心灵体验的写照？而更为现代的摄像机在画面中的存在似乎又暗示着一个当下的视角。张晓刚艺术的当代性就是这种对"过去"、"历史"反复观看，就是通过"失忆"对"记忆"进行不断地"修正"。

其实，对于特殊历史时期的集体与个体、公共与私人界限模糊这一事实经验的关注和表达从一开始的《大家庭》系列里就有所呈现。家庭既不是个人也不是集体，是个人与集体的一种关系和连接。张晓刚其实一直在以家庭的关系、家庭的方式来认识过去和现在的世界。《风景与电视》将这种特殊的关系和历史经验展现在另一个奇异的场景中，并使用了一对代表公共性与私人性的形象——广播喇叭与电视机，它们也经常出现在艺术家近几年的作品中。用于广播用的喇叭曾在中国特殊时期是人们获得信息的主要渠道，大到政府的通告与宣传，小到召唤集体中的某一个人，信息的传播与接受都是公共性的，或者说是在公共场所完成的。换句话说，那一时期人对外界的认知是以这样一种集体主义的、非私人化的方式实现的。而电视机则是改革开放以后普遍出现在家庭居室这样的私人空间中的，人获取信息的方式更为私密也更加有选择性。两种获取信息、认知世界的方式都存在于如张晓刚这样经历了文化大革命并见证了现在中国种种变迁的人们的经验中。张晓刚魔幻般地并置两个场景——辽阔的乡下田地间树立的电线杆和喇叭，和居室内沙发中望着电视机的人——来表达他对公共性与私人性、以及感性和秩序的思考。过去那开阔的田野所象征的社会主义集体主义的世界观和生活方式是否就是如今坐在沙发中的他这一代人认知世界、认识历史与现在的资源和背景？社会主义集体主义的方式、情怀与世界观是否依稀还存在于今天的现实？

Studio at Hegezhuang in Beijing　北京何各庄工作室

张晓刚是知识分子化的艺术家。其油画作品的视觉表达中所呈现的知识分子式的思考与心灵体验，在其巨幅摄影作品上直接呈现为文字的叙述和痕迹。在这次展览中，艺术家分别制作了"里"与"外"的场景图片，在这带有一点社会主义乌托邦色彩的生活环境中，艺术家在上面以日记的方式记录着他的思考、读书心得和生活琐事等等。痕迹在他的摄影作品里再一次成为关键词。作品里的电影图像，老电影中的场景和意象是否是艺术家书写的心理背景和当下存在、思考、体验的背景和基础？图像与文字的表面无关联背后是否依然暗示着历史和记忆是今天世界存在的一个维度？

从图像表层上，我们可以在查克·克洛斯（Chuck Close）、格哈德·里希特（Gerhard Richter）和张晓刚之间建立某种联系，这个联系可以丰富出一个图像世界的深度。查克·克洛斯的绘画是对肖像的理性的物质物理分析；格哈德·里希特的绘画是一种图像的哲学；而张晓刚的绘画是关于人的历史性的问题。

无论《大家庭》、《里和外》，还是《绿墙》系列，张晓刚持续反复地强调一种历史性。在他的绘画里，这种持续反复观看的历史和经历，被一次次地以记忆的方式所"修正"。"修正"是一个持续不断寻找方向的努力。

"修正"会直接让我们想起"修正主义"，这个词汇是对"社会主义"实践阶段所谓"正确方向"的反动，是对"社会主义"阶段走"资本主义"道路的称谓。今天重提"修正"无非是对今天的世界用一个历史的方式增加一种解释和认识。张晓刚的艺术在今天就具有这样一种意义。

尽管在世界的全局下，这段历史和经验从一个地区产生，但其集体主义的、解放全人类的乌托邦精神一直是具有着世界主义精神的。艺术家不断地在他的艺术中把这段过去以记忆的方式不断与今天相连，反复审视着它，正如《关于睡眠之二》中那张宁静而颤抖着光斑和泪痕的脸所带给人的疑问一样，过去的乌托邦精神是死去了，还是暂时的休眠，是在睡眠状态中等待黎明的苏醒？

这不仅是对世界的思考，也是对自我的位置的寻找。我想再用张晓刚的一篇日记来明确我们的现在的位置和问题：

"我的确真切地'感觉'到了，我们已真正地从'社会主义的康庄大道'上，迈进了经济全球化的高速立交桥，瞪直了双眼在这个多层的桥上一圈一圈地旋转着。从小学、中学到大学，到现在，我们耳边始终回响着一个声音：'我们正在面临着一个崭新的时代！'是的，我们永远在迈向一个全新的生活，这意味着你应当毫不犹像地放弃正在进行的思考，放弃你刚刚要熟悉的游戏，从而展开幻想的翅膀，乘着阳光赶快飞翔。"

Memory and Desire
回忆与欲望

Memory and Desire

Jonathan Fineberg

April is the cruellest month, breeding
Lilacs out of the dead land, mixing
Memory and desire, stirring
Dull roots with spring rain.
Winter kept us warm, covering
Earth in forgetful snow, feeding
A little life with dried tubers.

- T. S. Eliot, "The Waste Land" (1922)

It is the task of great artists to create the psychic spaces in which we can bring together our inner life with the inevitable facts of our existence. These border states are specific to the artist and to a moment in time and place. And yet the artist goes so deep into the specificities of this experience as to reach a common humanity which we can all understand. The brilliance with which Eliot crafts such a space in these first lines of "The Waste Land," using his art to open the border of our psychic space with the world, gives us room to ponder how we fit inside and outside together.

Green Wall - Slumber No. 2 (2008) is a painting by Zhang Xiaogang that takes us to the interface of memory and desire. We gaze down on the simplified volumes of a face. Is it a baby's face? She looks so beautiful. Is she sleeping? Is she about to awaken? Or has she drifted into death? The patch of yellow light that rests on her features has just a little too much shape, it is a touch too yellow against the near colorless forms to be about the observation of nature. Instead it directs us into the complicated pathways of reverie. The face fills the composition. It looms large, as in a dream, and the grey monochromy with which the artist renders it pushes the image back in time like a faded photograph.

"Grey gives people the sense of a being unrelated to reality, a feeling of the past," Zhang Xiaogang tells us. "...Grey represents my personal emotions and it is connected to my own temperament. I like the feeling of grey. It is a forgetful feeling that can also evoke a sense of dreaming...." *Green Wall - Slumber* continues the investigations of the artist's *Amnesia and Memory* paintings in its style and composition. Like them, it evokes the poignancy of memory and a nostalgia for the past. But it is not the real past we long for; it is a re-imagined past, shaped by the anxieties and the wishes of the present. It is what we wish we remembered.

"Memory isn't a thing that can actually present the past," an individual's memory undergoes "continuous revisions," the artist explained. In 1993, on a visit to his parents' home in Chengdu, Zhang Xiaogang happened upon some old yellowed photographs in a family album. Seeing his mother as a beautiful young woman took him by surprise and opened a portal of introspective fantasy. Through the old photograph, he reconfigures history in imagination. The photograph inspired the figure of the mother in the first group of the artist's celebrated *Bloodline: Big Family* paintings that began in 1994 [fig.1], but in the *Amnesia and Memory* paintings the presence of this photograph - now layered in idealizations, fantasies, associations, and desire - disperses into a conceptual space in which to contemplate the mysteries elicited in the softly sensuous but indistinct face of a work such as *Green Wall - Slumber.*

The "Green Wall" of the title, however, remains unseen in this painting. *Green Wall - Wooden Bench* (2008) shows a melancholy interior with a slatted wooden bench, a radio trailing a long cord that is plugged into an extension, a small leather case on one end of the seat, and a clock hanging on the wall, that reminds us of our unwilling obedience to the passage of time. But halfway up the wall is the ubiquitous green paint - the "official" paint of communist China. We see the same green wall in *Green Wall - Military Uniform, Green Wall - Room with Flashlight, Green Wall - White Bed, Green Wall - Reader*, and *Green Wall - Two Single Beds* (all new works in this exhibition). We find the institutional green of these interior walls in a waiting room, behind the family couch, in various bedrooms (as though we might expect it to enter and define the private space of all bedrooms). It also covers the exterior walls of government buildings and compounds all over China. Looking at the green wall we could be inside or outside, in a public or private space; the green wall defies such boundaries. The green wall defines a psychological space that is more than the happenstance of place and observation. *Green Wall - Slumber* occupies that mental space.

Another current series called *In-Out* also complicates these boundaries. In the earlier (2006) paintings in this series we find a single point of sharp focus. *In-Out No. 1* [fig.2] has a crisply described flag pole in the foreground of a landscape otherwise blurred, like an out of focus snapshot; In *In-Out No. 7* [fig.3], the artist clearly delineates a bare bulb hanging from a cord, while blurring the rest of the room. In these works the single, sharply focused element stands out like an enigmatically vibrant detail in a dream or in an early memory where all else seems unclear and evanescent. It is often the seemingly most

insignificant detail, Freud tells us, that unlocks the hidden meaning of a dream. The bare light bulb hanging from a cord in paintings like *Green Wall - Military Uniform* or *Green Wall - White Bed* rings with a potentiality of insight, affirmed by the artist's own train of association: "The history or memory has gone, but the memories or the past are still fresh somewhere. So we can see the bulb." Memories emerge in detached fragments, charged with feeling, and the fluidity with which they flow through our consciousness parallels the instability of our grasp of history, which is constantly under revision.

For a Chinese painter this exploration of history has particular meaning in the wake of the successive campaigns that constituted the Cultural Revolution (1966-1976). History was required to be forgotten. The famously forbidden "Four Olds" - "Old Customs, Old Culture, Old Habits, Old Ideas" - led to the massive destruction of historic temples, books, some people even destroyed their family photo albums in fear. The government sent Zhang Xiaogang's parents to jail for their political beliefs when he was fourteen and then dispatched him to a rural farm in Yunnan. "I felt that we were really living in a struggle between remembering and forgetfulness," Zhang Xiaogang recalled. The entire youth of China were "sent down" from the cities to the countryside for "re-education." They were forced to renounce their parents and to sever all relations in order to become the children of the Party. Many of them became swept up in the idealism of destroying the past for a Utopian future of social equality, but they were too young to grasp the importance of remembering and to understand the way in which their hope for a better future required the historical values that led people to find common purpose. Instead, armed bands of seventeen and eighteen year old Red Guards overran the country bringing about a reign of chaos.

In 1969 troops were dispersed across the country to restore order. But after a brief lull another, different "revolutionary" campaign ensued. No one was untouched and "virtually everyone in China, at various stages of that movement, participated," writes Xujun Eberlein in her stories of the Cultural Revolution. "There was often

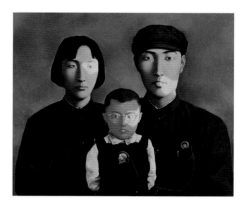

Bloodline: Big Family 1994 Fig.1
血缘 - 大家庭 1994

no clear divide between victims and victimizers, and people took turns to be in both positions."

The Cultural Revolution ended with the death of Mao and a month later the overthrow of the ruthless "Gang of Four" in October 1977. Entrance exams were reinstituted for the newly reopened colleges after a ten year hiatus and Zhang Xiaogang entered the prestigious Sichuan Academy of Fine Art with an extraordinarily talented class from a decade long backlog of gifted students. The years 1977 to 1979 were a period of reflection as young people returned to the city to find no jobs, often relying on the parents they had denounced to live. History itself changed again as they looked back to compare official and unofficial versions of the decade they had just lived through.

"For me," Zhang Xiaogang told an interviewer, "the Cultural Revolution is a psychological state, not a historical fact. It has a very strict connection with my childhood, and I think there are many things linking the psychology of the Chinese people today with the

psychology of the Chinese people back then." But the changes in China today have been so rapid that even a decade ago seems like far distant time. In so far as Zhang Xiaogang's paintings address memory and history, they are also intrinsically political. They concern the disjunctiveness of history and events. In a new series of paintings entitled *Description* (also titled with the precise day and year of their production) the artist directly addresses this cognitive dissonance. Watching television, he takes a snapshot of the screen when he sees an image that interests him, he paints it and then inscribes a text over the image of something else he has been thinking about which may have no relation to the image at all. The layering of simultaneous streams of information, intersecting and interacting but coming from altogether different places also concerns the way in which we experience events and the power of our minds in structuring them.

"The thing is to find a truth which is true for me," the Danish philosopher Kierkegaard noted in his journals, and Zhang Xiaogang was profoundly influenced by his reading of existentialist writers (Kierkegaard, Sartre, Kafka) and by both psychoanalysis and Zen philosophy. "By chance I read a book by the important Japanese Buddhist Suzuki Daiseki on the relationship between Zen and psychoanalysis, combining them to talk about the meaning of life, the analysis of dreams, the meaning of existence. The book had a profound influence on me."

As we find ourselves sliding further and further into a virtual world with increasingly mutable boundaries between nature and culture, memory and history become important spaces of cultural and personal re-invention. History has always been rewritten by the needs and exigencies of the present; but today the boundaries of subjectivity have become so permeable that history has become imbued with nostalgic sensuality as never before. Although contemporary China has had a particularly pronounced dissonance between the official and the remembered past, the issue of the revision of history and memory has a rapidly increasing global resonance. This may be one of the reasons for the pronounced impact of Chinese painting today and of

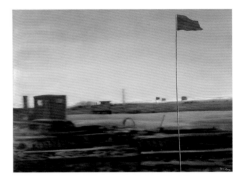

In-Out No.1 2006 Fig.2
里和外之一 2006

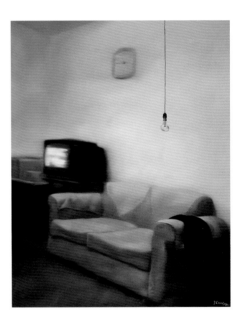

In-Out No.7 2006 Fig.3
里和外之七 2006

Zhang Xiaogang's painting in particular. We have long used sleep to sort the emotional residues of past and present, the real and unreal. But in the world today fragmented psychic time meets "natural" time ever more frequently in our waking life. In the vast erotics of memory and history we need great painters more than ever before.

1. T. S. Eliot, "The Waste Land," (1922), *The Complete Poems and Plays 1909-1950* (N.Y.: Harcourt, Brace, and World, 1952), 37.

2. Zhang Xiaogang, cited in Julia Colman, "Big Family: The Later Work of Zhang Xiaogang," in *Zhang Xiaogang* (Tampere, Finland: Sara Hildén Art Museum, 2007), 160-2.

3. The series began, he said, in 2000 with *Amnesia and Memory: My Girl*. "I was missing my daughter," then six years old and living in another city. Zhang Xiaogang, lecture delivered at The University of Illinois at Urbana-Champaign, October 23, 2007, with simultaneous translation by Professor Gary Xu.

4. Zhang Xiaogang, cited in Julia Colman, "Big Family: The Later Work of Zhang Xiaogang," in *Zhang Xiaogang* (Tampere, Finland: Sara Hildén Art Museum, 2007), 159.

5. Sigmund Freud remarks upon "the remarkable preference shown by the memory in dreams for indifferent, and consequently unnoticed, elements in waking experience" already in his discussion of the literature on dreams: Sigmund Freud, The Interpretation of Dreams (First Part), in *The Standard Edition of the Complete Psychological Works of Sigmund Freud, Volume IV*, trans. James Strachey (London: Hogarth Press and the Institute for Psychoanalysis, 1953), 18ff. Later Freud repeatedly discusses the use of such seemingly "unimportant" details in the analysis of dreams, as in Sigmund Freud, The Interpretation of Dreams (First Part), in *The Standard Edition of the Complete Psychological Works of Sigmund Freud, Volume IV*, trans. James Strachey (London: Hogarth Press, 19), 173: "In the manifest content of the dream only the indifferent impression was alluded to,..." and so on.

6. Email from Zhang Xiaogang via his assistant Amanda Zhang, to Jonathan Fineberg, 8-14-08.

7. Zhang Xiaogang, lecture delivered at The University of Illinois at Urbana-Champaign, October 23, 2007, with simultaneous translation by Professor Gary Xu.

8. Xujun Eberlein, "Swimming with Mao," *Walrus* (July-August, 2006).

9. From an interview with the artist conducted by Francesca Dal Lago, May 2, 1999, cited on http://www.legacy project.org/index.php?page=art_detail&artID=870/.

10. Dru, Alexander. *The Journals of Søren Kierkegaard*, Oxford University Press, 1938, entry for August 1, 1835.

11. Zhang Xiaogang, lecture delivered at The University of Illinois at Urbana-Champaign, October 23, 2007, with simultaneous translation by Professor Gary Xu.

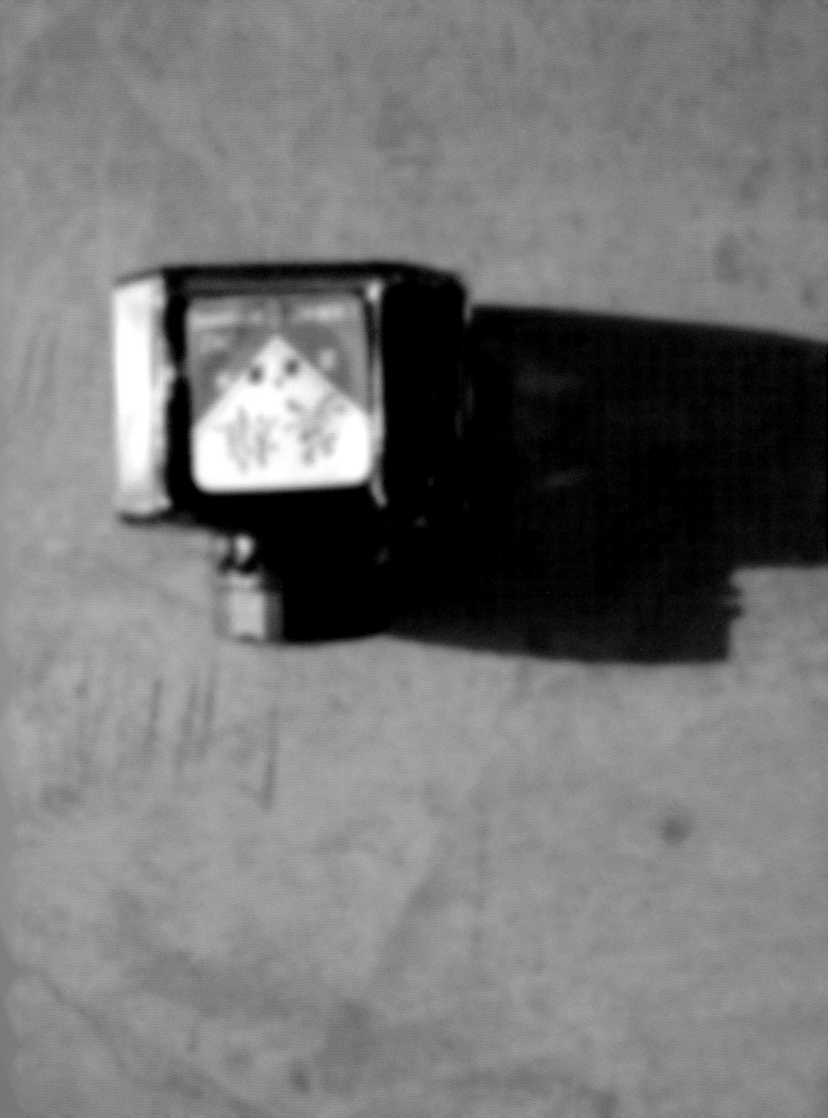

回忆与欲望

乔纳森·法恩伯格

四月是最残忍的一个月，
荒地上长着丁香，
把回忆和欲望掺在一起，
又让春雨催促那些迟钝的根芽。
冬天使我们温暖，
大地给助人遗忘的雪覆盖着，
又叫枯干的球根提供少许生命。

—T.S.艾略特，《荒原》（1922）

伟大艺术家的任务在于创造精神世界，从而将人们的内心生活和其存在这一必然事实结合起来。这些临界的领域专属于艺术家和时空中的某些特定时刻。 然而艺术家如此深切地涉入这些特殊的体验，为的是从中提炼出一种为大众所理解的人性。在《荒原》开篇的几行诗句中，艾略特的高明之处在于他运用艺术的语言勾勒出一个世界，打通了人类精神家园和外部世界，给予我们空间去思考如何将内心世界和外在世界结合起来。

张晓刚的作品《绿墙——关于睡眠之二》（2008）将我们带到记忆和欲望的衔接点。我们注视着画面上简化的面孔。这是一张孩子的脸吗？她是那样动人。她睡着了吗？还是快要醒来？抑或是正在临近死亡？照在她脸上的那片光晕具有过分的实体感，光晕的黄色调在周围几近无色的形体的映衬下显然过于鲜明，这个场景完全不可能是现实世界的再现，它是通向晦涩梦境的幽渠秘径。面孔弥漫在整个画面上，如同在梦境中一般，而艺术家采用单一的灰色调子则将画面带入往昔，宛若一张褪色的照片。

"灰色带给人一种和现实疏离的感觉，一种怀旧的感觉，"张晓刚告诉我们。"……灰色表达了我的个人情感，这也和我的性格有关，我喜欢灰色的感觉。这是一种遗忘的感觉，却能唤起梦境……"。《绿墙——关于睡眠》在作品风格和画面构成上延续了艺术家对"失忆与记忆"这个主题的探索。像之前的作品一样，它唤起了我们辛酸的回忆和对往昔的殷切思念。但这不是人们渴望获知的真实过去，而是一个被重新构想的过去，它被当下的种种焦虑和愿望所塑造，它只是我们想要记住的那个部分。

张晓刚解释道："回忆并不能真正呈现过去"，每个人的回忆都经历着"不断地修正"。1993年回成都老家探亲时，张晓刚偶然在家中的相册里发现了一些泛黄的老照片。他惊讶地看到自己的母亲曾是那样年轻美貌，于是便陷入了一种自省式的冥想之中。通过这张老照片，他在脑海里重新构想了一段历史。在张晓刚1994年开始创作的《血缘：大家庭》[图一]系列中，母亲的形象就源于家中那张老照片，这也是他代表作中最早的一组作品。但在《失忆与记忆》系列中，这张照片被植入理想、幻境、联想和欲望的多重维度之中，渗透

……我的艺术感总一直倾向于某种"封闭性"、"私意性"。一般来讲，我总是习惯于"<u>在此离此</u>"去观察和体验我所处的现象，以及我们所拥有的沉重的历史。这样讲，并非意味着我要试图去接近一个"愤世嫉俗"的遁世者。也许这完全是自己的性格和气质的原因。我常常下意识地要站在事物的表面去体验某种隐藏于事物表层之下的那些东西，那些被人称为"<u>隐秘的东西</u>"。比如人在寂寞时的冥想，对我来讲，是最失充满魅力的时刻。也许也正论去了我才可能成为一个关注重大社会问题的"文化型"

在一个观念时空里，对神秘之物的沉思默想凝练为一张张柔美但又各具特色的面孔，正如《绿墙——关于睡眠》所展示的那样。

我们在这件作品中并没有看到标题中的"绿墙"，而《绿墙——长椅》(2008) 则展现了一种伤感的内在情绪：一条木质长椅，拖着长长电线的收音机插在接线板上，长椅的一端放着小皮箱，墙上挂着时钟，这些东西勾起我们对时间流逝的无奈和感伤。墙的下半部分刷成了绿色——那是一种在当时的中国随处可见的绿色，是共产主义中国的"官方"色。这次展出的新作：《绿墙——军大衣》、《绿墙——有手电筒的房间》、《绿墙——白色的床》、《绿墙——读书者》和《绿墙——两张单人床》中，我们同样看到了这种绿色。在候诊室里，在家庭的沙发后面，在各种各样的卧室里都能看到这种千篇一律的绿色墙面，就好像我们能通过这种绿色能进入并区隔所有卧室中的私人空间。但在中国，政府建筑和机关大院的外墙也会使用这种绿色。看到绿墙的时候，我们可能是在室内或室外，公共场所或私人空间；绿墙是一种对界限的藐视，它超越了具有偶然性的场所与事实，界定出一种普遍的心理空间，即《绿墙——关于睡眠》所占据的心理空间。

张晓刚近年的系列作品《里和外》再一次模糊了界限。在这个系列的早期作品（2006年）中，我们总是发现一个单一而尖锐的焦点。《里和外之一》[图二]的前景里清晰地描绘了一面旗帜，而其余的景象却十分模糊，就像一张失焦的快照。而在《里和外之七》[图三]中，艺术家则清晰地描绘了一个吊在电线上的灯泡，房间中的其他部分亦被模糊。这些作品里，个别聚焦清晰的元素鲜明强烈，就好像梦境中或早期记忆里某个难以解释而又跳跃不已的细节，至于其他部分则模糊且转瞬即逝。弗洛伊德告诉我们，这些看上去无关紧要的细节，往往能揭开梦境背后隐藏的真正意义。如《绿墙——军大衣》或《绿墙——白色的床》中吊挂的灯泡就能引发出一种潜在的领悟。艺术家自身的经验也证实了这一点："历史或记忆已经过去，但某些过去的片段仍然清晰可见。这就说明了为什么我们会看见那个灯泡。"回忆是承载情感的碎片，在我们的意识中流转，它的不确定性正如我们把握历史的不确定，总在经历着不断的修正。

对于张晓刚这样一个经历了文化大革命（1966—1976）政治风潮的艺术家而言，探究历史更是别具意味。那段历史被强制性地遗忘。著名的"破四旧"（"旧思想、旧文化、旧风俗、旧习惯"）运动导致了对文物古迹，历史古籍的巨大破坏，出于强烈的恐惧，一些人甚至

销毁了他们的家庭相册。张晓刚14岁时，政府因为政治信仰问题将他的父母关进监狱，把他送到云南农村进行劳动生产。张晓刚回忆道："我感到我们确实生活在一种回忆和遗忘的挣扎之中"。全中国的城市青年"下乡"接受"再教育"，他们被迫离开父母，脱离一切关系以成为党的儿女。他们中的大多数人被灌输这样的理想主义观念：要通过毁灭过去才能走向社会平等的乌托邦未来。但他们当时太过年轻，无法体会记忆的重要性，也无法理解要走向更美好的未来，需要在历史价值观的引导下找到人们心中共同的目标。而当时的状况是，正值十七、八岁的红卫兵武装起来四处串联，造成了国家的混乱。

1969年，人民军队被派遣到全国各地去恢复社会秩序。但经过了一段短暂的平静期之后，紧接着又爆发了新一轮的"革命"运动。这场革命席卷全国上下，"在中国，几乎每个人，每个阶层都参加了这次运动"徐军在她的著作《文化大革命》中写道，"受害者和施害者之间通常没有明确的划分，人们轮流扮演这两个角色。"

文化大革命在毛泽东逝世及1977年10月"四人帮"的粉碎之后划上句号。在间断了10年之后，高考制度重新恢复，张晓刚从十余年间累积的众多优秀考生中脱颖而出，以优异的成绩考入著名的四川美术学院。1977到1979年间，广大知青返城却没有就业机会，他们通常依赖父母维持生活。当他们以亲历者的身份来比较官方和民间对这十年的解释时，发现历史就由此改变了。

张晓刚曾对一位采访者说："对我来说，文革是一个心理历程而非历史真实。它和我的童年紧密相连，我想很多事情会将过去和现在中国人的心理连接起来。"但是今天中国的变化速度如此之快，以至于十年前的一切看起来都仿佛是遥远的过去。张晓刚的作品呈现出回忆和历史，同时也包含了政治因素。它着重于表现历史叙述和真实事件之间的非一致性。一组题为《描述》的摄影作品（每件作品的题目为完成的确切时间）就直接呈现出这种认知上的不一致。艺术家看电视的时候，遇到感兴趣的画面便用快照拍摄，然后在画面上题写一段文字，文字的内容是当时他脑海里出现的事物，可能和画面毫无关系。来源各异的信息流层叠交织，这也影响了我们经历事件的方式和主观重构事件的力度。

丹麦哲学家克尔凯郭尔在他的日记中写道："寻找一个对我而言是真理的真理"，张晓刚深受存在主义作家（克尔凯郭尔、萨特、卡夫卡）的著作，心理分析学说以及禅宗理论的影响。"一次偶然的机

会我读到日本高僧铃木大拙的著作，里面论述了禅宗和心理分析学说的关系，结合二者来讨论生命的意义，梦境的解析以及存在的意义。这本书深深地影响了我。"

我们发现自己正不断陷入一个虚幻的世界之中，自然和文明之间的界限越来越暧昧不清，记忆和历史就为文化和个人的再创造提供了重要空间。历史总是根据当下的需求和迫切需要被改写，但是时至今日，主观的界定无处不在，历史也因此被前所未有的怀旧情绪所感染。虽然在当代中国，官方的历史和民间的回忆呈现出明显的不一致性，但有关历史和记忆的修正问题也在全球范围内迅速激起了反响。这也许是当代中国的绘画艺术，尤其是张晓刚的艺术拥有如此显著影响的原因之一。我们总是用睡眠来整理过去和现在、真实和非真实的各种情感片段。但是当今世界在我们清醒的生活中，破碎的心理时间和"物理"时间越来越频繁地相遇。就在对记忆与历史的巨大欲望之中，我们比从前更需要伟大的画家。

1. T. S.艾略特，《荒原》（1922），《诗歌和戏剧全集1909-1950》（纽约Harcourt, Brace, and World出版社，1952年版），第37页。

2. 张晓刚，引自Julia Colman的文章《大家庭：张晓刚近作》，发表于《张晓刚》（芬兰坦佩雷Sara Hildén美术馆，2007年），第160-162页。

3. 张晓刚说这个系列始于2000年创作的《失忆与记忆：女孩》，"我当时很想念我的女儿"，她那时六岁，住在别的城市。引自张晓刚2007年10月23日在伊力诺依州立大学厄巴纳—香槟分校的演讲，由Gary Xu教授现场翻译。

4. 张晓刚，引自Julia Colman的文章《大家庭：张晓刚近作》，发表于《张晓刚》（芬兰坦佩雷Sara Hildén美术馆，2007年），第159页

5. 西格蒙德·弗洛伊德曾在他的著作《梦的解析》（第一部分）中论述道："在梦境中回忆起来的大多是在清醒时觉得无关紧要，根本不被注意的细节"，《西蒙德·弗洛依德心理学著作全集》标准版第四卷，James Strachey译（1953年伦敦Hogarth 出版社和心理分析学会出版），18ff。后来弗洛伊德反复讨论这些看似"无关紧要"的细节在梦境分析中的作用，如在《梦的解析》（第一部分）中所写道的："只有那些无关紧要的印象被用来暗示梦境的实际内容……"（《西蒙德·弗洛依德心理学著作全集》标准版第四卷，James Strachey译，1953年由伦敦Hogarth 出版社，第173页），诸如此类。

6. 引自张晓刚经由其助手张敏发给Jonathan Fineberg的邮件，2008年8月14日。

7. 张晓刚在伊力诺依州立大学厄巴纳—香槟分校的演讲，2007年10月23日，由Gary Xu教授现场翻译。

8. 徐军（Xujun Eberlein），《和毛主席一起游泳》，发表于《海象》（2006年7、8月合刊）。

9. 摘自1999年5月2日Francesca Dal Lago对艺术家的采访，文字内容取自　http://www.legacy-project.org/index.php?page=art_detail&artID=870/。

10. Dru, Alexander，《索伦·克尔凯郭尔日记》，1835年8月1日刊，牛津大学出版社，1938年出版。

11. 张晓刚在伊力诺依州立大学厄巴纳—香槟分校的演讲，2007年10月23日，由Gary Xu教授现场翻译。

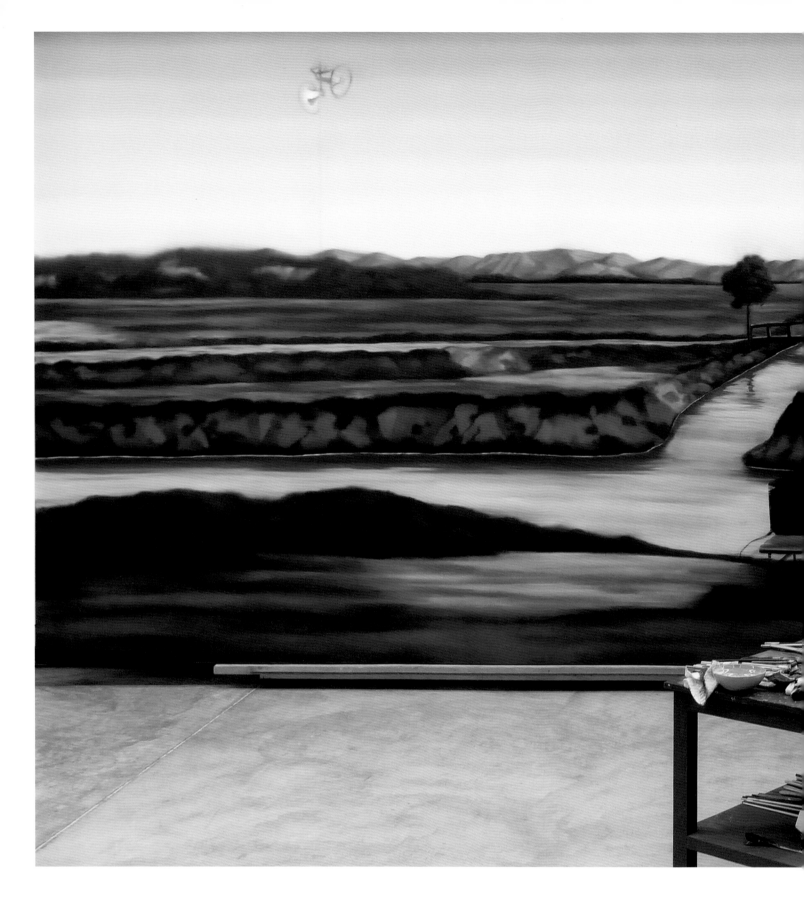

2008 painting *Green Wall – Landscape and Television* at Hegezhuang studio in Beijing
2008年，于北京工作室创作油画《绿墙 - 风景与电视》

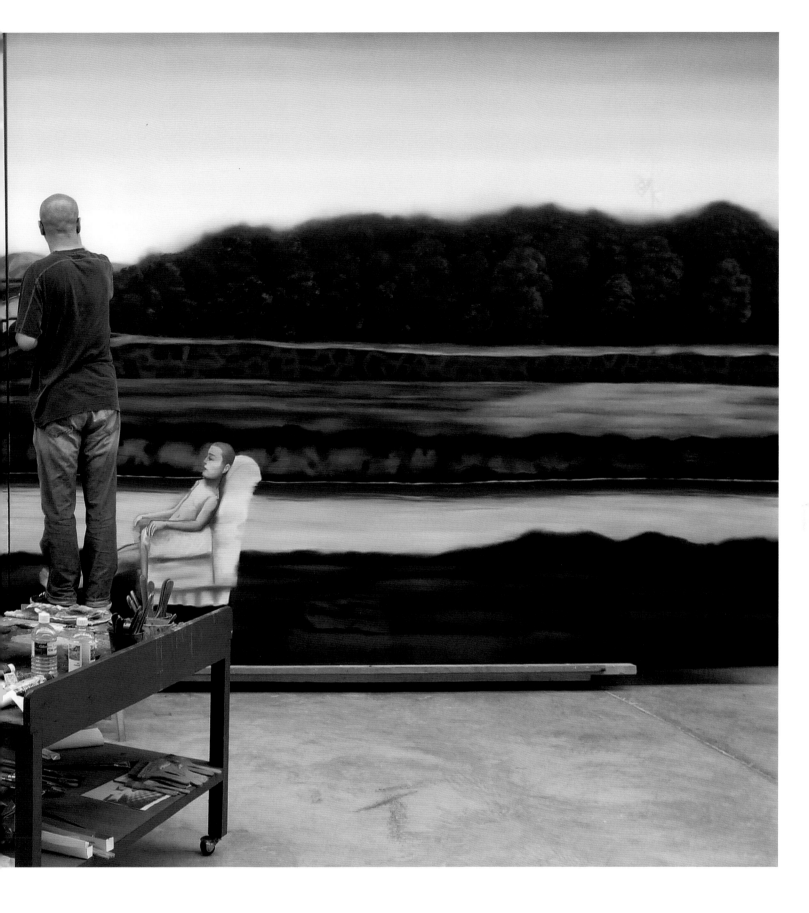

List of Exhibited Works
展览作品

Description of September 17, 2008

描述2008年9月17日

2008

Silver ink and oil on color photograph

180 x 350 cm

彩色摄影，银色签字笔，油彩

180 x 350 厘米

Description of September 18, 2008

描述2008年9月18日

2008

Silver ink and oil on color photograph

180 x 350 cm

彩色摄影，银色签字笔，油彩

180 x 350 厘米

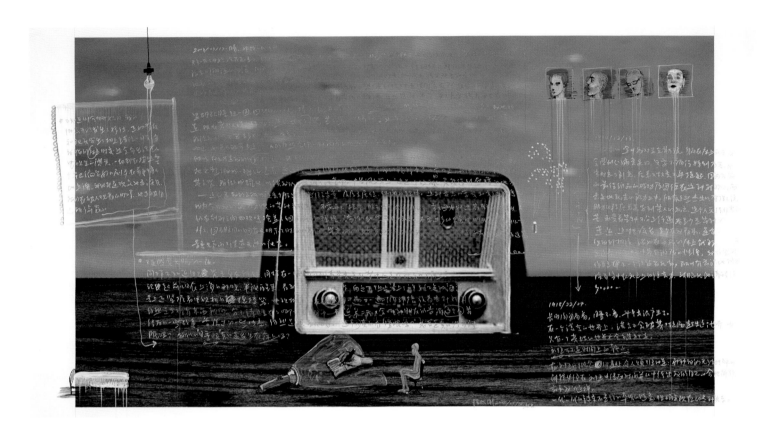

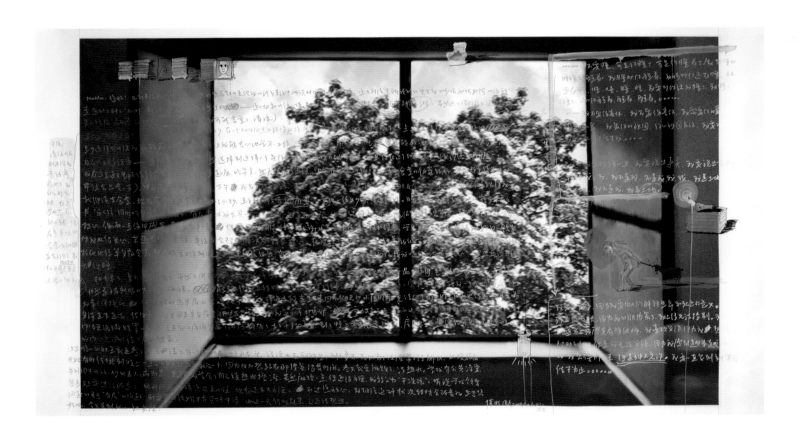

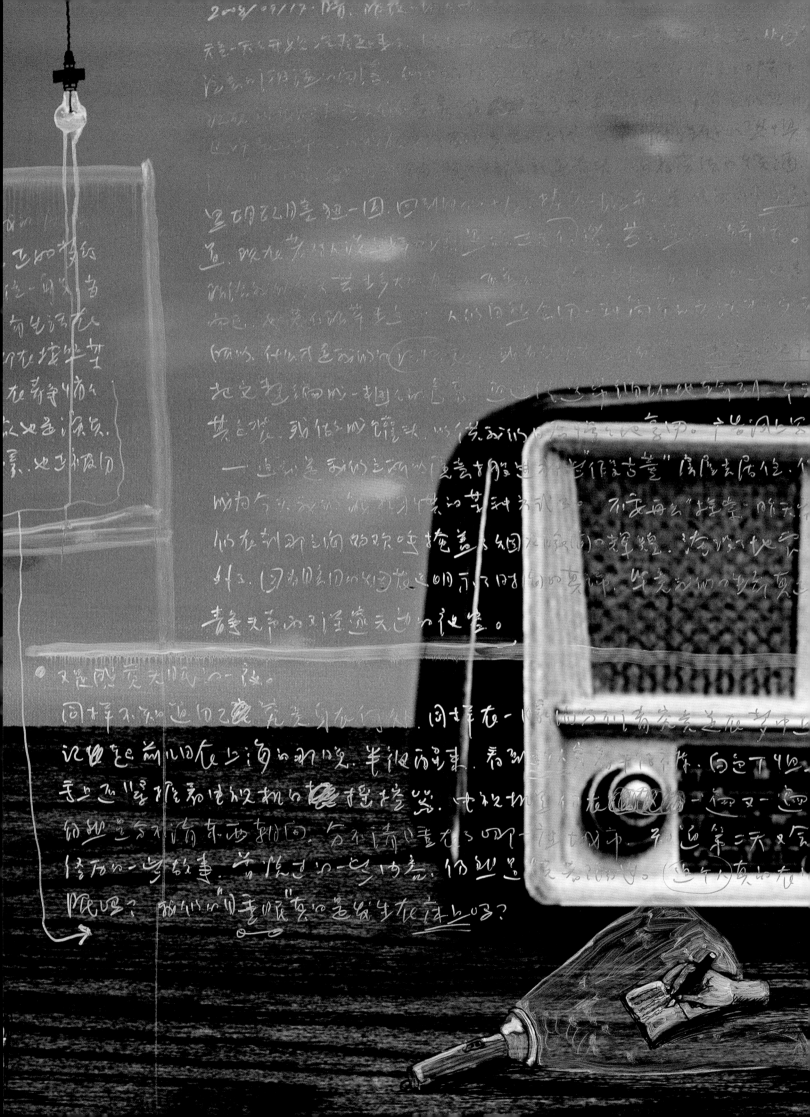

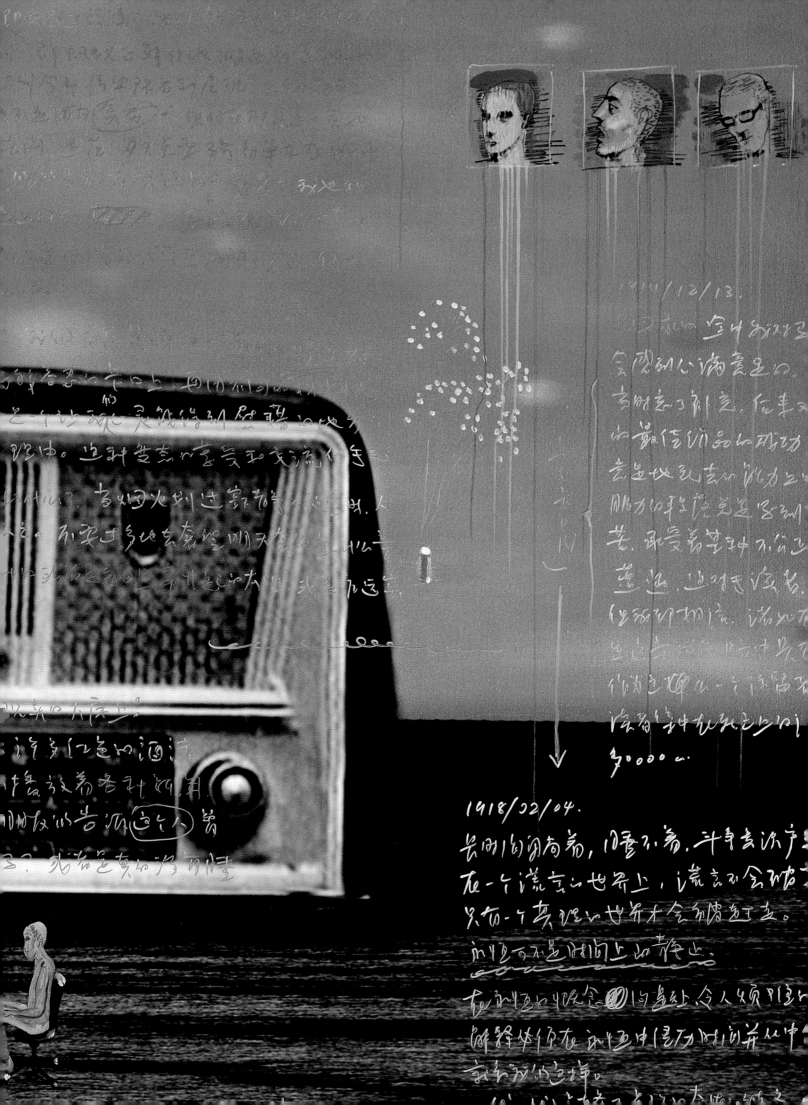

Description of September 17, 2008

September 17, 2008 Sunny, heavy rain last night

The weather is getting cooler day by day, I can feel fall is on its way in the air . Looking out from the window, rays of Sunlight shine through the lush foliage onto a damp, unnoticable corner, seems like it's still sizzling hot, but the actual temperature is decreasing everyday. I see ants busying away transporting food – isn't now a bit early to start gathering up and storing away food for the winter? Could it be that they also begin to sense various types of "crisis" and "turning point", which would occur this year? Perhaps it is so, people in this crazy and ever changing era, the feeling of fear from the bottom of their hearts are not due to poverty, thinking back on the truly penniless 80s, a few friends, there's nothing on our bodies but flesh and bones, drinking very cheap alcohol, although depressed and lost, still ride our bicycles to aimlessly wander around the city, return to our little room, holding a bunch of books that can't be fully understood and reading them furiously, but we have never felt poor. I know, if I spoke of these to others now would seem too pretentious and luxurious. Perhaps it is so, do not hope that "memory" could really bring us any great energy or power now a days, right? From the present day point of view, "memory" is only a product that could be consumed and materialized, that's all, if it would no longer serve its function, people will naturally find a way to eliminate it...

Hence, what is our memory? Or what is the memory that we need in today's world? We tirelessly revise our memories again and again, motify them into parcels, repeatedly send them through conveyor belt to a gate where we can tolerate, then we package them with different materials, or make them into can goods so we can enjoy them at a later date. The commercial slogan could be "This is a place where we can come for spiritual solace and comfort." – This is why we are willing to move into those "phony antique" houses to live or for vacation. It seems like we are able to get accustomed to this bizzare way of enjoyment and interaction. Do not "explore" anymore what had happened yesterday, when the fireworks scratch the surface of a quiet night sky, people's cheering noise overwhelms the fireworks' magnificence, and overwhelms the deaths brought by the earthquake. Do not over anticipate any surprises that will be happening tomorrow, because the splendid fireworks had already demonstrated to us the true essence of time, after all what we have to face in life is the sun that will rise up everyday, or the ever so quiet and infinite night sky.

Another night feeling sleepless.

It's always the same, I didn't know where I was. I didn't know whether I was in a dream or actually in my bed! Remembering a few nights ago in Shanghai, I woke up in the middle of the night, I saw a person wearing jeans and a white T-shirt with many red wine stains, his hand holds tight to the television remote control, the television is displaying repeatedly various news clips, as always I couldn't tell where I was, which city was I sleeping in, I know some friends will be telling this person some stories they have experienced in the past, and things that have been said in the past, yet I would feel as if all these happened in another life time. Is this person really asleep? Or is he really awake? Do our sleep really happen on beds?

I don't know when did this start, my perception of "bed" began to change, as if dream and reality have switched places, when I lay on the bed I would suddenly feel like I am living inside a television program, everything act quietly according to some script written long ago, we are the audience as well as the actors, as we are being watched by others, we are also peeping in on ourselves.

Excerpts from The Diaries of Franz Kafka:

December 13, 1914
On the way home told Max that I shall lie very contentedly on my deathbed, provided the pain isn't too great. I forgot and later purposely omitted to add that the best things I have wirtten have their basis in this capacity of mine to meet death with contentment. All these fine and very convincing passages always deal with the fact that someone is dying, that it is hard for him to do, that it seems unjust to him, or at least harsh, and the reader is movied by this, or at least he should be. But for me, who believe that I shall be able to lie contentedly on my deathbed, such scenes are secretly a game; indeed, in the death enacted I rejoice in my own death, hence calculatingly exploit the attention that the reader concentrates on death, have a much clearer understanding of it than he ...

February 4, 1918 (translated from Chinese text)
Lying down for a long time, sleepless, conflicting consciousness occurred.

In a world of lie, lie won't be drove away from this world by its opposite side, and only a world of truth would be forced out.

Eternity is not the stillness of time.

What confuses and troubles us in the question of eternity is: those explainations that we couldn't understand must be found in experiencing time in eternity, from this we obtain our own reasonable explainations, just like us.

The chain of bonds being past down from generation to generation are not your intrinsic qualities, but they are the various kinds of already existing relations.

Zhang Xiaogang, in Beijing
September 17, 2008

描述2008年9月17日

2008/09/17 晴　昨夜一场大雨

天气一天天开始凉爽起来了，风中正能感受到一些秋天的气息。从窗外望去阳光透过茂密的树叶散落在那些不被人注意的阴湿的角落，似乎仍然炎热，但其实气温正在一天天地降下。我看见一群蚂蚁正繁忙地搬运着食物——现在就开始为冬天储蓄奔波是否太早了点？难道它们也开始意识到今年将出现各种"危机"，各种"拐点"？也许是这样的，人们在这个疯狂多变的年代，发自心底深处的恐惧却恰恰不是因为贫穷，想到在那真正一贫如洗的八十年代，几个朋友，身上除了皮就是骨头，喝着劣质的烧酒，虽然苦闷、迷茫，每天总要骑着单车在城市里胡乱瞎逛一圈，回到自己的小屋，捧着一堆并不真正明白的书狠狠地看，但从来没有觉得自己贫穷。我也知道，现在若对人说这些话，显得过于奢侈，甚至显得"矫情"。也许是这样的，不要去奢望"记忆"真的能给我们今天带来多大的力量，不是么？在今天看来"记忆"不过也是一个可以消费可以为我们带来物质的产品，仅此而已，若不能带来这些，人们自然会用一种简单的方法将它灭掉……

所以，什么才是我们的记忆呢？或者什么才是我们今天需要的"记忆"呢？我们不厌其烦地一遍遍地修正它，把它整编成一捆捆的包裹，通过传送带循环地输到一个我们能够容忍的卡口上，再用不同的材料将其包装，或者做成罐头，以供我们日后慢慢地享用。广告词上写上"这是一个让我们心灵能得到慰藉的地方"——这就是我们之所以愿意搬进那些"假古董"房屋去居住、休闲的理由。这种变态的享受和交流似乎已成为今天我们能够习惯的某种方式了。不要再去"探索"昨天究竟发生了什么了，当烟火划过寂静的夜空时，人们在刹那之间的欢呼掩盖了烟火瞬间的辉煌，淹没了地震带来的死亡。不要过多地去奢望明天会发生什么意外了，因为炫目的烟花已明示了时间的真谛，毕竟我们的生命真正要面对的或者是每日照常升起的太阳，或是永远寂静无声而又深邃无边的夜空。

又是感觉无眠的一夜。

同样不知道自己究竟身处何处。同样在一瞬间分不清究竟是在梦中还是在现实的床上！记起前几日在上海的那晚，半夜醒来，看到这个人穿着牛仔裤、白色T恤上染上了许多红色的酒渍，手上还紧握着电视机的遥控器，电视机里仍在一遍又一遍循环播放着各种新闻，仍然是分不清东西朝向，分不清睡在了哪一座城市，知道第二天又会听到朋友们告诉这个人曾经历的一些故事，曾说过的一些内容，仍然是恍如隔世。这个人真的在睡眠吗？或者是真的没有睡眠吗？我们的"睡眠"真的是发生在床上吗？

不知道从何时开始的，我的"床"的概念开始发生了移位，正如梦幻和现实发生了相互错位一般，当我躺到床上时突然会有生活在电视里的感觉，一切都在按照某个早已编写好的剧本在静悄悄地上演，我们即是观众又是演员，我们在被人观看的时候，也在被自己所窥视。

选自卡夫卡日记：

1914年12月13日

"在回家途中我对马克斯说，躺在床上死去我会感到心满意足的，只要痛得特别厉害。我当时忘了补充，后来又故意不再提起，因为我写的最佳作品的成功原因便在这种能够心满意足地死去的能力之中。所有这些杰出的、有强大说服力的段落总是写到某人的死亡，这个人死得十分痛苦，承受着某种不公正待遇或至少是某种冷酷的遭遇，这对于读者，至少在我看来，是有感染力的。但我却相信，诸如在等死的床上能够感到满足这类描写暗中具有游戏的性质。我希望能作为这么一个弥留者死去，所以有意识地利用读者集中在死亡上的注意力，头脑比他清醒得多……"

1918年2月4日

"长时间躺着，睡不着，斗争意识产生了。

在一个谎言的世界上，谎言不会被其对立面赶出这个世界，而只有一个真理的世界才会被赶走。

永恒可不是时间上的静止。

在永恒的概念问题上令人烦难的是：那种我们无法理解的解释必须在永恒中经历时间并从中得出我们自己的合理解释，就像我们这样。

一代一代的链条不是你的本质的链条，但确是现存的各种关系。"

张晓刚，于北京

2008年9月17日

Description of September 18, 2008

Dear MaMa,

I have gotten your previous letters, please don't worry. It's the same as many of the letters you have been sending me in a long time, the "tragedies" you have been believing I encounter here do not exist, they never happened – everything is the same as usual, they are all in your imagination, or should I say they are your predicitions. Of course, these all come from your long periods of worry, insecured, and absolute hoplessness in people (My words may be too severe, apologies.)

The truth is I am doing very well here. Although I am alone and far away from home, living and working in a foreign land without many friends, it can be a bit lonesome, but this is good for me. At least it enables me to receive a certain peaceful and tranquil feeling, it allows me to concentrate on study, work, be far away from the noisy and busy life in the past, it allows me to organize and clarify my thoughts, re-examine my many actions – this is also one of the reasons why I would choose to come to a city I actually don't like all that much, and staying in the corner of such a city.

I am living everyday with a set routine here, wake up at seven in the morning, eat breakfast, then go to the classroom and give lessons, in lunch time I eat at the cafeteria (the food here is great, I would bring you here to have a taste sometime), after lunch I learned to take naps, in the afternoon either I continue to have class or stay at home to paint, at times some friends would ask me out for dinner, if no one does then I would go to the cafeteria as usual. There are some new improvements made to the cafeteria, they added various pan-fried dishes to the menu, fifty jiao (0.50 yuan) a MaPo Tofu dish, one yuan (1.00 yuan) per pan-fried meat dish, and they taste great. At night, I usually stay in my room read books or write letters while listening to my favorite music. Some people suggested me to get a second hand television, I am still considering, but I really don't like those fitional, unrealistic television programs. My health is great, don't worry, once in a while I would get a cold, but that is very normal, let alone this would be a boost to my metabolism. I get along with very well with my colleagues and students, my supervisor cares a lot about me, if I ever got into trouble or needed help, our work unit would help out, so please don't worry about me. Next to my room lives the director of the communist party office in our school (his family does not live in town, so he also lives in the single's dormitory), he usually returns to his room from work at 11 at night, sometimes he would knock on my door with a bottle of chinese wine, so we drink a bit, talk, then go to bed.

Fall is here, summer is finally gone, although we don't need to cool off by pouring cold water on the ground, or washing the bamboo mat on the bed with cool water, but here is still different from Kunming, the average temperature is still at 30°C, every morning I would be awake by the strong sun lights, but by night falls the temperature would signicantly drop. Every weekend, I would be the only person left in the single dormitory of our floor, it's very quiet. I always clean the hall way on my side of the floor, this makes me feel very good every time I walk back to my little room. Since there is no one else at the place, I could walk around nude, it's liberating. Also, since it's a single's dormitory, we do not need to pay for electricity, therefore, I got myself a small stove heater, I can boil water, or once in a while boil some eggs and the like. I have learned to fix up lamp covers with a harden paper, so my room is now filled with all kinds of lamps in all different sizes, at night I will adjust them according to my taste and mood, my room suddenly became very lively and has a nice tone and mood, this fills my heart with warmth and imgination.

The only complaint I have is that there is only one bathroom and one faucet on our two story high building, the shower is also in this bathroom. In the summer, we would often queue up in line to take shower, it usually starts from shortly after dinner until one in the morning. I am always the last one to go, because I don't like to wait on line, it's such a waste of time. In the winter it gets worst, there is no hot water. The public bath houses at the school only opens in the weekend, but it's also too crowed. Since I've started to live here, I learned to wipe my body with hot water I boiled, although it's not very convenient, but I called it "dry cleaning". I heard that the school is about to improve on all these, then I will invite you to come over to live here for a short period of time, now it's simply too inconvenient. Please don't worry too much, I believe all these will be improved upon very soon. Also, you asked about "distribution of houses" previously, that I can only be qualified to apply if I were married, and I haven't thought yet about when will this day arrive,

All right, I will stop here, take care!

P.S.: Pleaes don't ever send me money and food again. I don't need anything here, and I don't need to spend a lot of money, room and board is provided by the work unit, I get some supplements from the government for my meals, and as a teacher, I get an extra 6 yuan every month as "material budget".

From "Nijinsky's Notes": (translated from Chinese text)

......don't you sleep, but you slept, but you are asleep. I think I am still awake when I sleep, when I sleep you are awake, when I am awake you are still asleep, sleep, sleep, sleep, I want to tell you I am asleep, I am asleep I am asleep, and you are awake, awake, awake......

......I don't want to hurt you, I don't want to hurt you, I need your love, you also need my love, I love your home country, your home country is you, I want to tell you, I belong to you, you belong to me......

......I want to be a clown, I want to tell the truth, I want to tell it all, you are afraid of me, I, I am not me, not me, me, me, I am earth, I am earth, I am not me, I am earth.

I want to write a lot, because I want to explain to people the meaning of life and death. I can't write very fast, because my muscle is tired, I can no longer control it. I am a preacher, I feel pain around my shoulder, I like writing, because I want to help people through my writing. But I can't write, because I am feeling more and more tired. I want to stop, to end, but God doesn't allow it. I have to write until God wants me to stop......

Zhang Xiaogang, in Beijing
September 18, 2008

描述2008年9月18日

MaMa：您好！

几封来信都收到了，勿念。正如您长期以来给我的许多来信中所说到那些事一样，这几封信里所说到的关于我的生活如何如何以及所遭遇的种种"不测"，都是不存在的，没有发生过的——这一切和以往一样，都是来自您的想象，或者说来自某种臆测。当然，这一切都源自您长期以来的焦虑、危机感和对人的彻底绝望。（我可能言重了，请谅。）

实际上我在这里生活得很好。虽然一个人远离故乡，在一个相对陌生的环境里工作、生活，甚至朋友很少，相对孤独一点，但这样对我是有好处的。至少这样可以使我能够获得某种安宁，让我能专心地学习、工作，远离过去喧闹繁杂的生活，使我能好好地清理一些自己的想法，反省自己的许多行为——这也是我为何要突然选择到这样一个实际上我并不喜欢的城市里来，并且呆在这个城市的边缘角落的原因之一。

我在这里每天生活得很有规律，早上七点起床、吃早餐，然后进教室上课，中午在食堂打饭吃（这里食堂的饭菜很好，什么时候您来时我带您去品尝一下），中午学会了睡个午觉，下午或者继续上课，或者就在家画画，晚饭有时候朋友会约我出去吃，没人约我就继续去食堂。现在食堂也改革了，增加了小炒，五毛钱一份麻婆豆腐，一元钱一份炒肉，味道很好。晚上我一般呆在自己的寝室中看看书、写写信，同时听听自己喜欢的音乐。有人建议我去买一台二手电视，我正在考虑，但我很讨厌那些虚假的电视节目。我的身体很好，不用担心，偶尔一点伤风感冒，属正常事情，何况这样对身体的新陈代谢也是一种促进。我和同事、学生的关系相处得挺好的，领导对我也很关心，若遇到有什么困难，单位都会帮忙解决的，请您放心。在我寝室的隔壁，就住着我们学校的党办主任（他因家属在外地，故他也住单身宿舍），他一般会工作到晚上11点才回房休息，有时他就会提一瓶酒来敲我的门，找我喝上两口，"谈谈心"，然后再回去倒头便睡。

秋天来了，夏天终于过去了，虽然不用每天拿凉水冲地降温，用凉水擦床上的竹席，但这里毕竟与昆明不同，气温仍然在30℃，每天清晨仍然是被刺眼的太阳给晒醒，但是到了晚上很明显地气温降了很多。每到周末，我们这一层单身宿舍就我一个人，非常安静。我常常用拖把将我住的这半层的过道拖干净，这样每当我走上楼回到自己的小屋时会觉得心情很好。反正也没人，可以光着身体走来走去，很自由。这里因是单身宿舍，用电不花钱，所以我买了一个小电炉，可以烧点水，偶尔也煮两个鸡蛋什么的。我学会了一种用硬纸做灯罩的方法，于是我的房间里每个角落都有了大大小小的灯，到了晚上可以随意调配，房间里一下显得很有生气和情调，让我内心充满了温暖和想象。

这里唯一的缺点就是整个两层楼只有一个厕所一个水龙头，洗澡也在厕所里。到了夏天，我们为了洗澡常常得排队，从晚饭后开始有时候得排到晚上一点。一般我总是最后一个，因为我不想站在那傻等，浪费时间。冬天就更麻烦了，没热水。学校有公共澡堂，每到周末开放，但也是人满为患。来这后我学会了自己烧热水擦澡，虽然麻烦一点，但还很方便，我称之为"干洗法"。听说学校领导答应马上要进行改造了，到那时我再请您过来小住，现在还不太方便。不过您放心，我相信这种状况会很快会改变的。至于您

问起的关于"分房"的问题，那要等到结婚才有资格申请，而这一天何时到来，我还没想过。

好吧，今天先到此，祝安康！

又及:请您以后别再给我寄钱寄吃的了。我在这里什么的都不缺，在这里也花不了什么钱，住房是单位的，食堂吃饭国家有补贴，教师每月除工资外还有6元钱的"材料费"。

选自《尼金斯基手记》：
"……你不要睡，可是你睡了，可是你睡着了。/我想睡的时候我醒着，我睡时你醒着，我醒时你还在睡，睡，睡，睡，我要对你说我睡了，我睡了我睡了，而你醒着，醒着，醒着……

……我不要伤害你，我不要伤害你，我需要你的爱，你也需要我的爱，我爱你的祖国，你的祖国是你，我要对你说，我属于你，你属于我……

……我要扮演小丑，我要说出事实，我要说出全部，你怕我，我，我不是我，不是我，我，我，我是土地，你是土地，我不是我，我是土地。

我要写很多，因为我要向人们解释生命和死亡的意义。我无法写得太快，因为我的肌肉累了，我已经无法控制。我是个殉道者，我感觉肩膀很痛，我喜欢写作，因为我想借此帮助别人。但是我无法写作，因为我感到越来越疲倦了。我想停下来结束，但是神不允许。我要一直写到神要我结束为止……"

张晓刚，于北京
2008年9月18日

Green Wall - Landscape and Television

绿墙 - 风景与电视

2008

Oil on canvas
300 x 800 cm

布面油画
300 x 800 厘米

Green wall - Military Uniform

绿墙 - 军大衣

2008

Oil on canvas
200 x 300 cm

布面油画
200 x 300 厘米

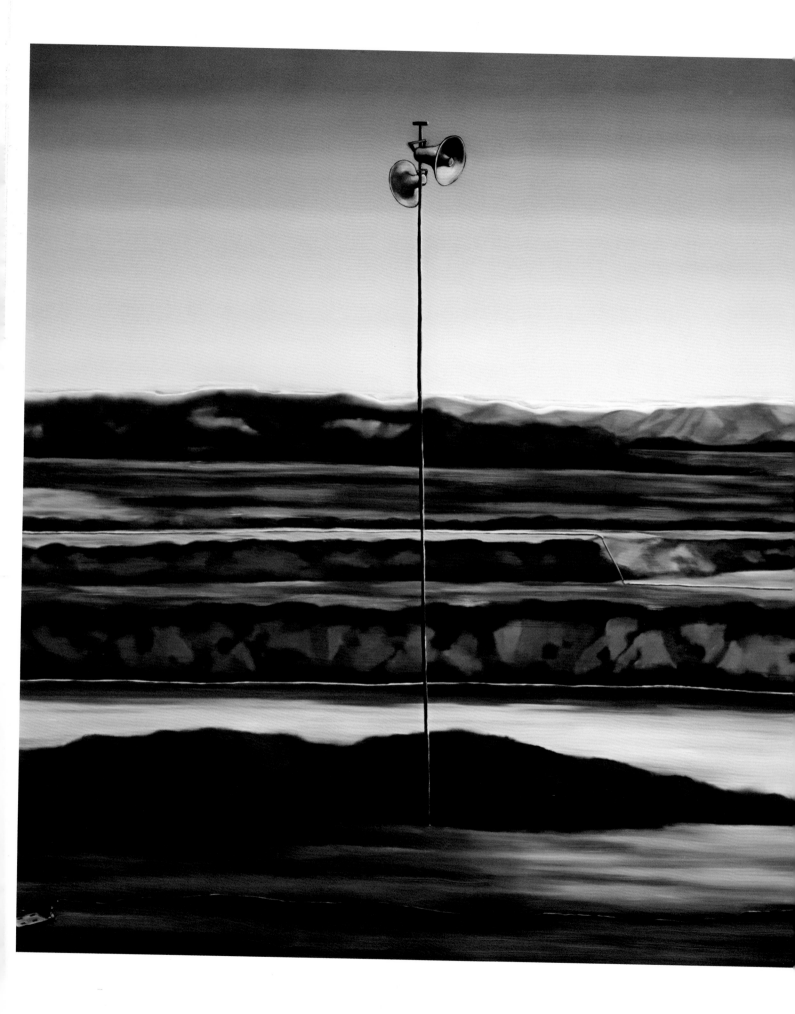

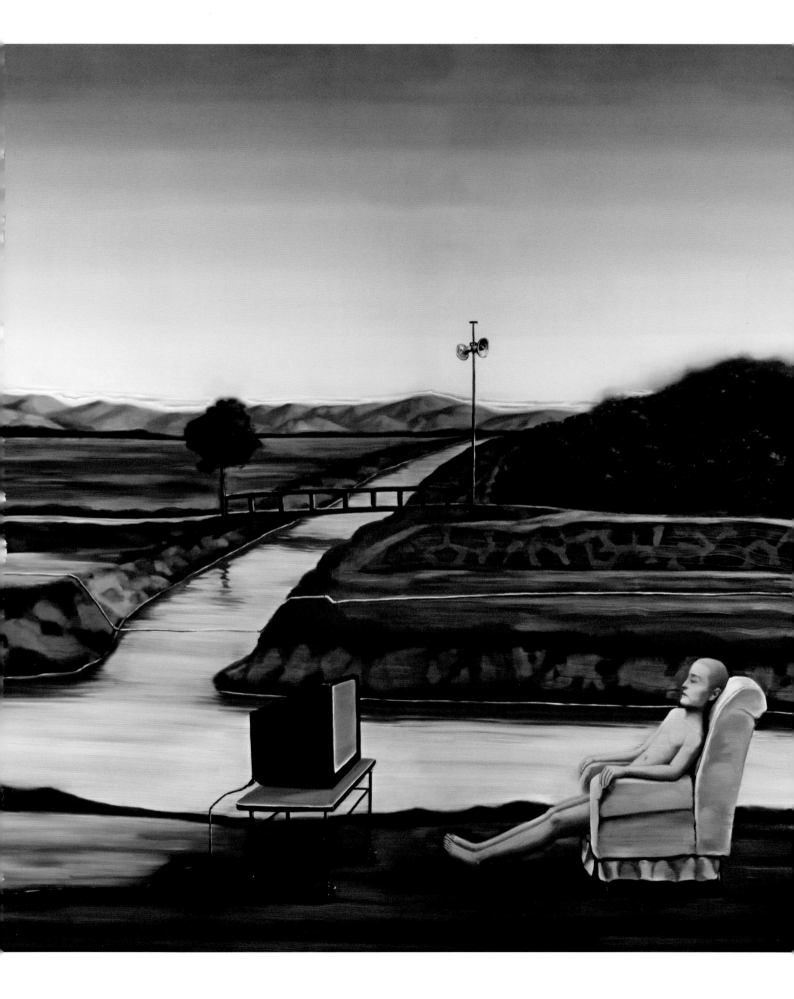

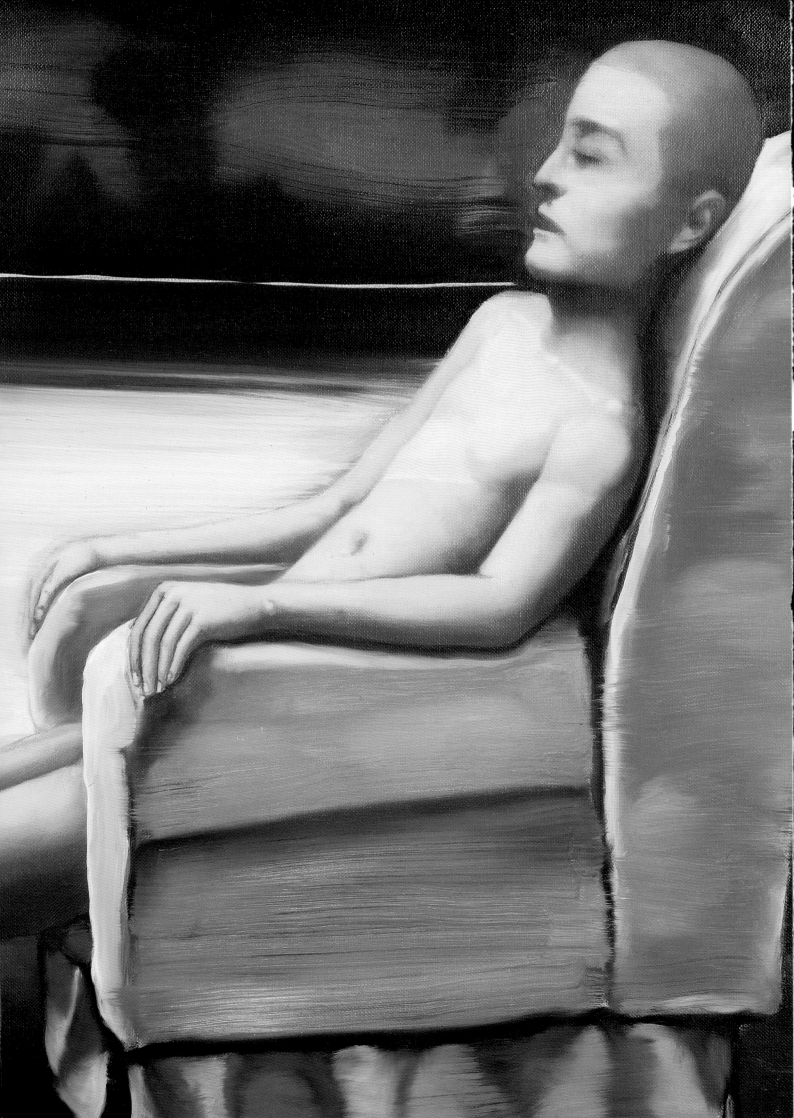

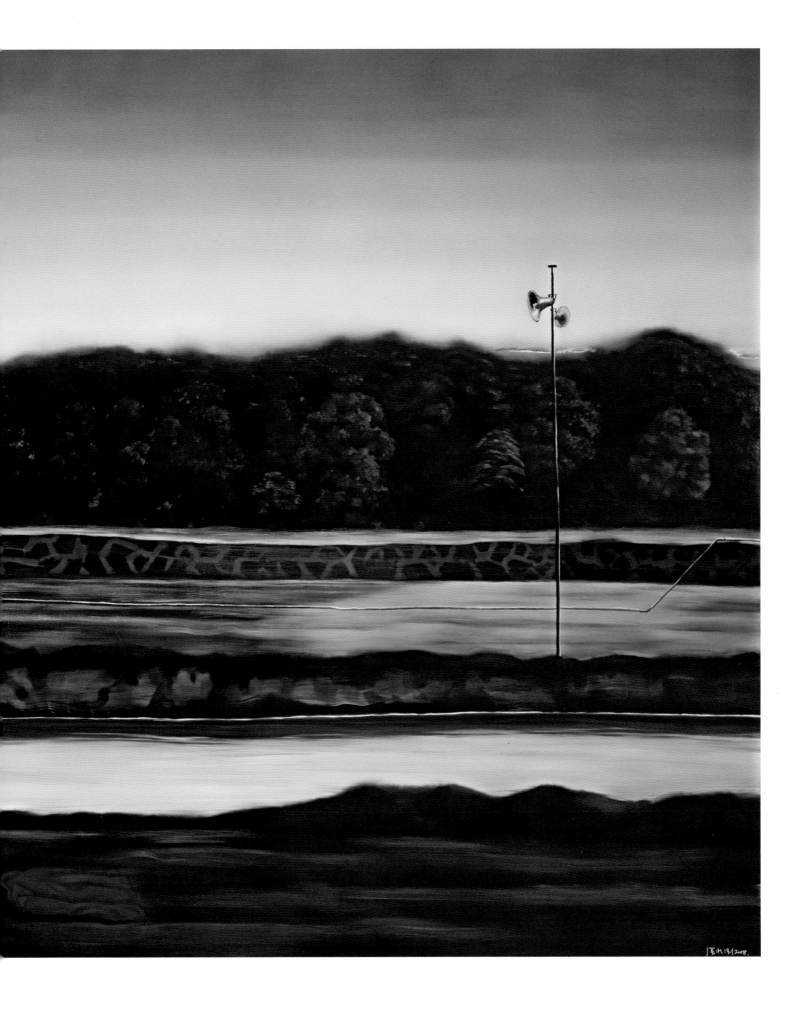

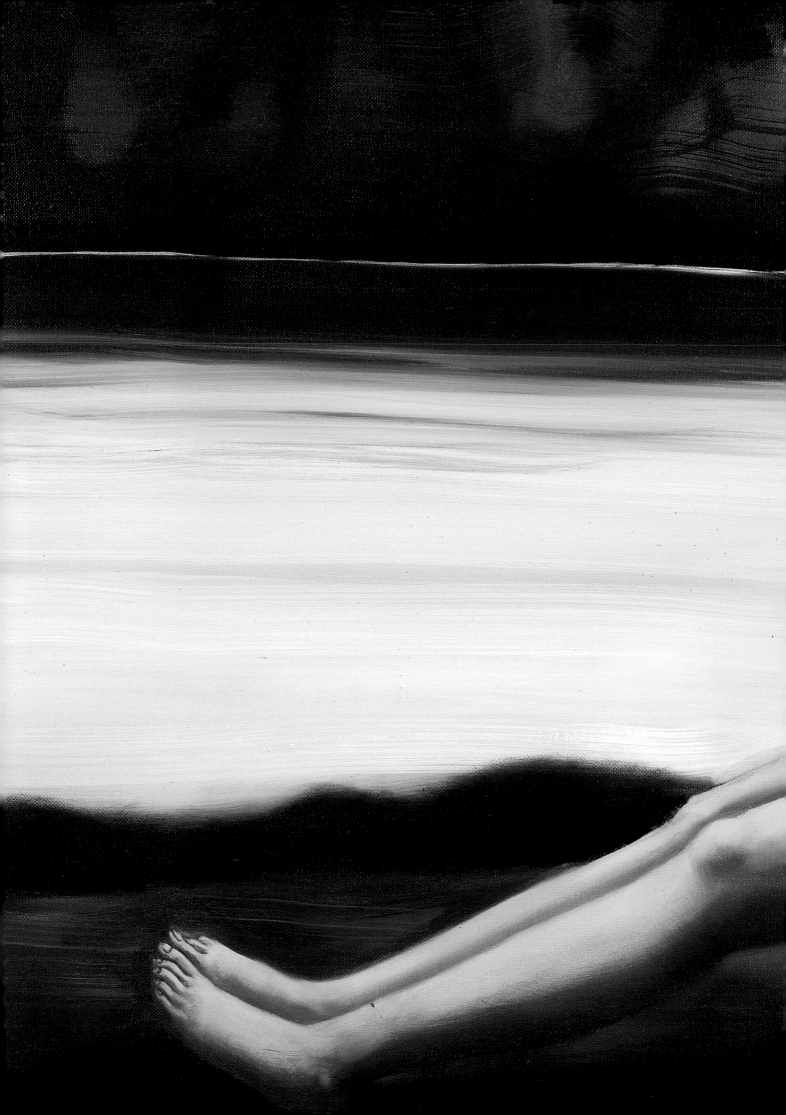

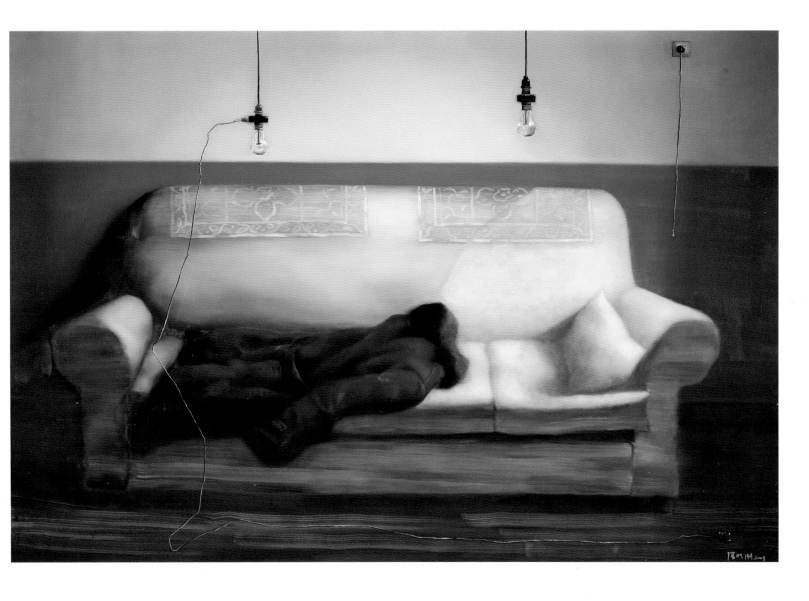

Green Wall - Two Single Beds

绿墙 - 两张单人床

2008

Oil on canvas
300 x 500 cm

布面油画
300 x 500 厘米

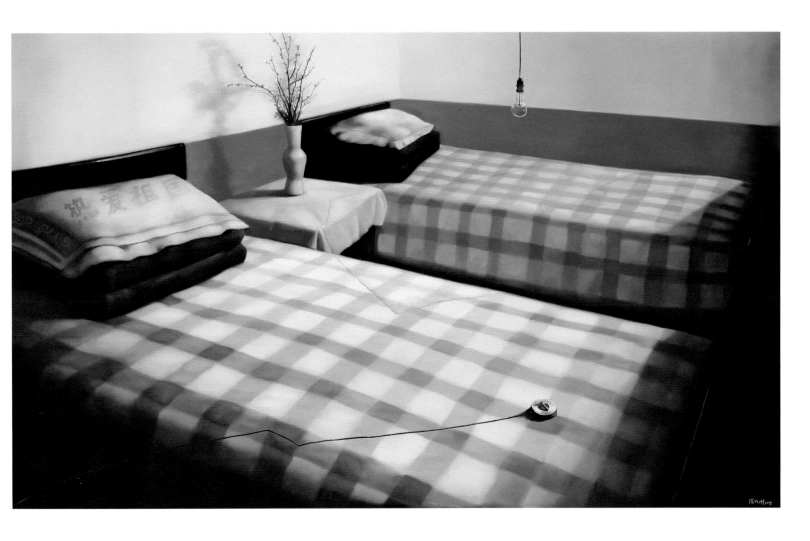

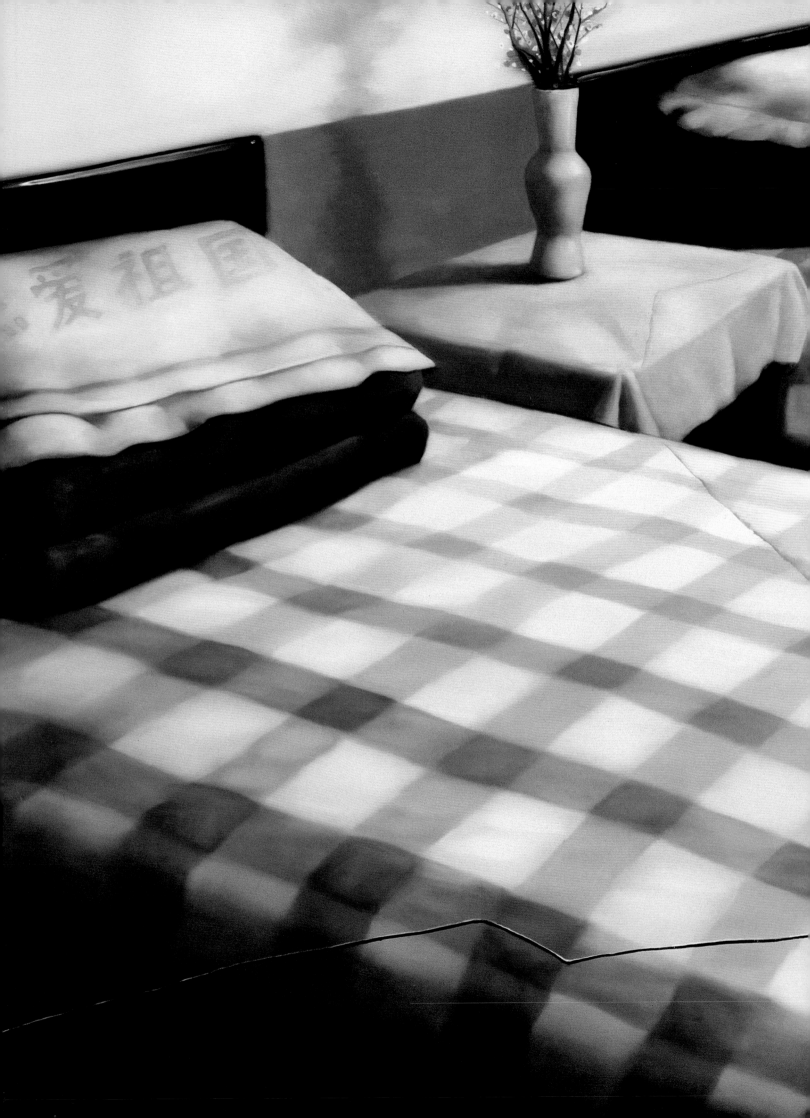

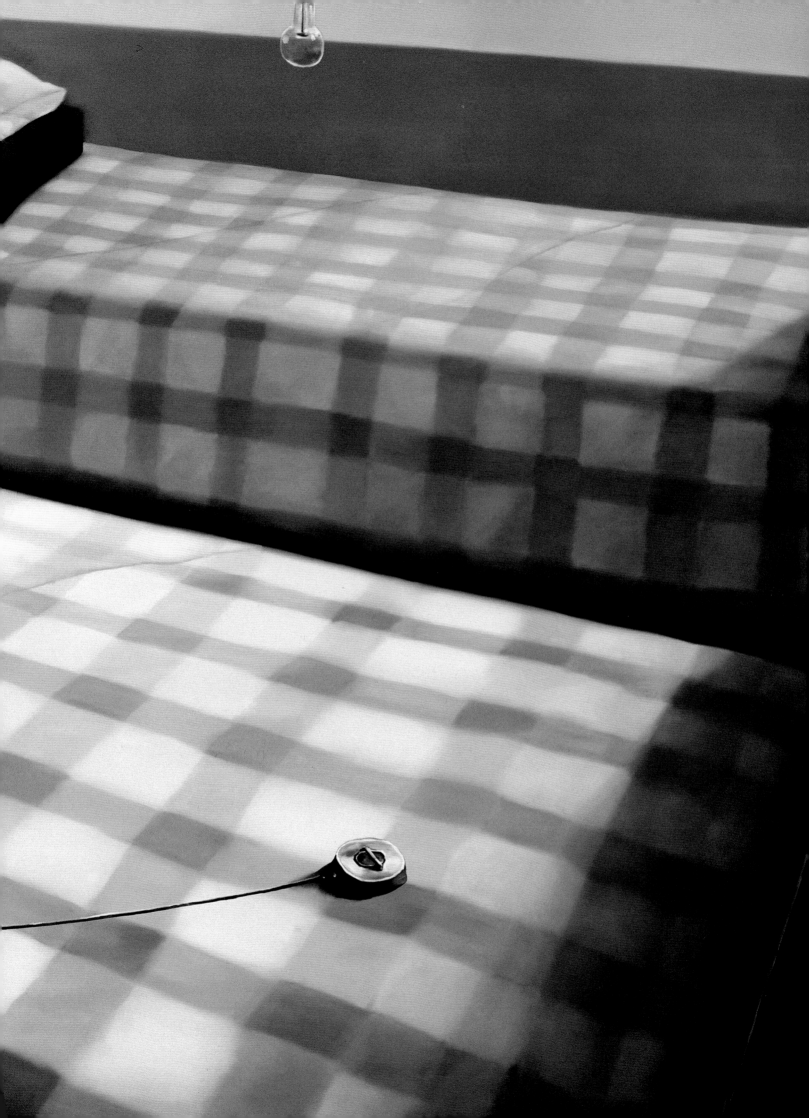

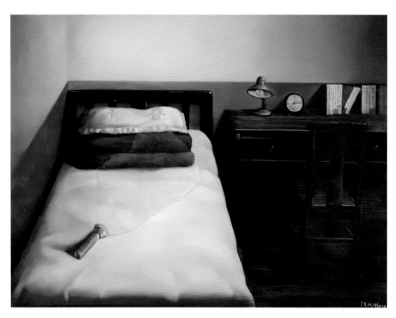 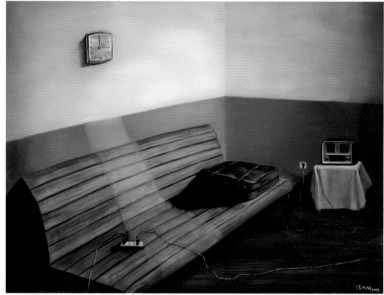

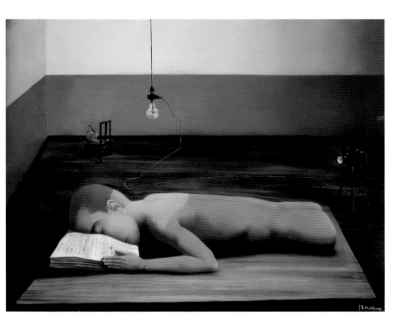
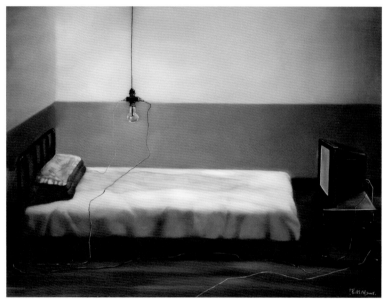

Green Wall - White Bed
绿墙 - 白色的床

2008

Oil on canvas
150 x 200 cm

布面油画
150 x 200 厘米

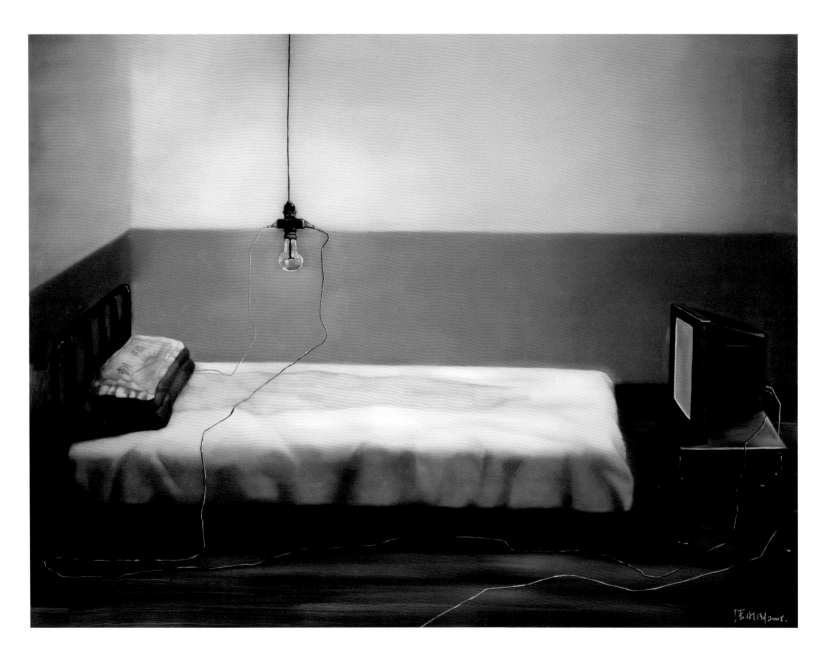

Green Wall - Reader
绿墙 - 读书者

2008

Oil on canvas
150 x 200 cm

布面油画
150 x 200 厘米

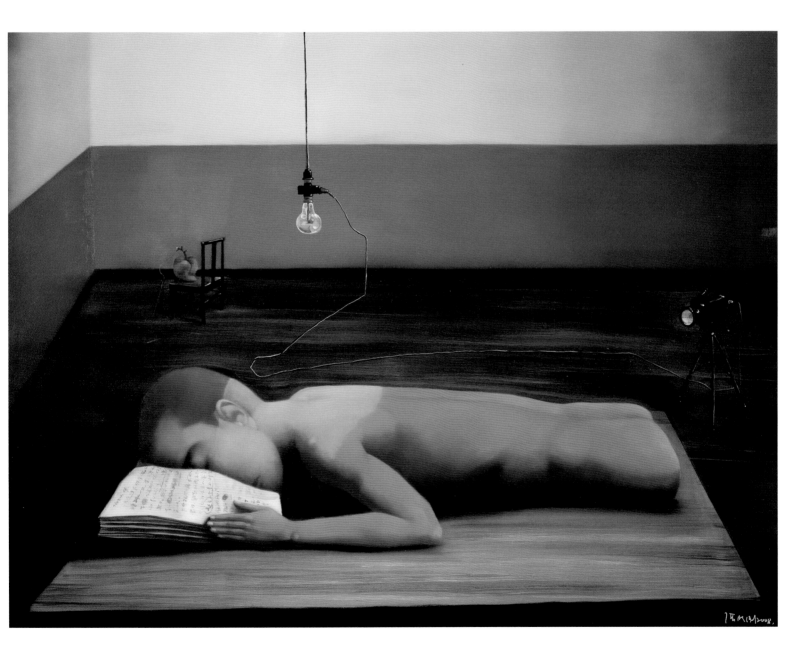

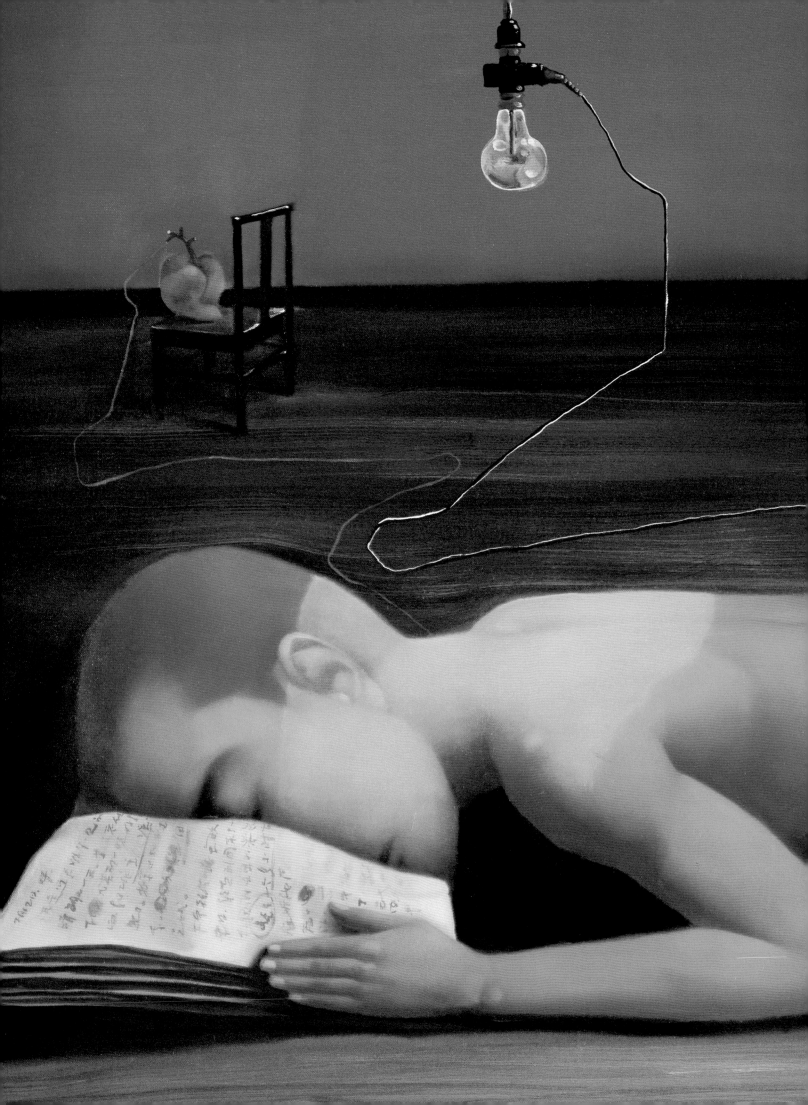

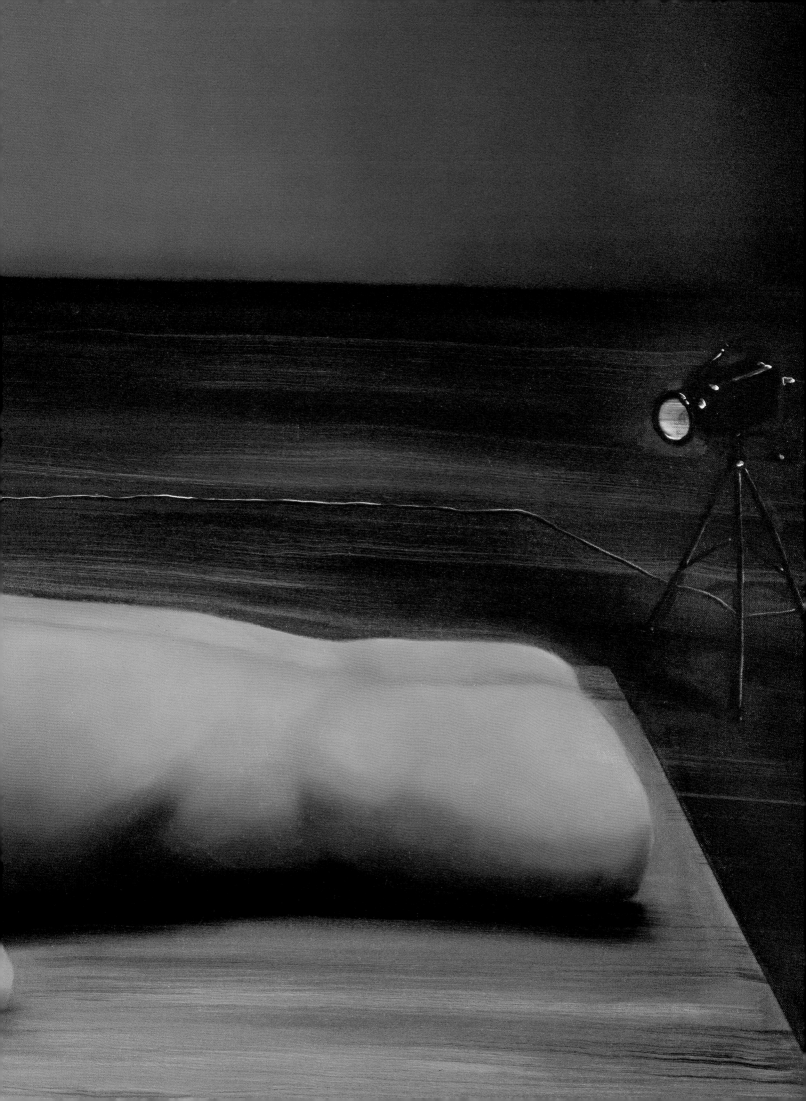

Green Wall - Room with Flashlight

绿墙 - 有手电筒的房间

2008

Oil on canvas
150 x 200 cm

布面油画
150 x 200 厘米

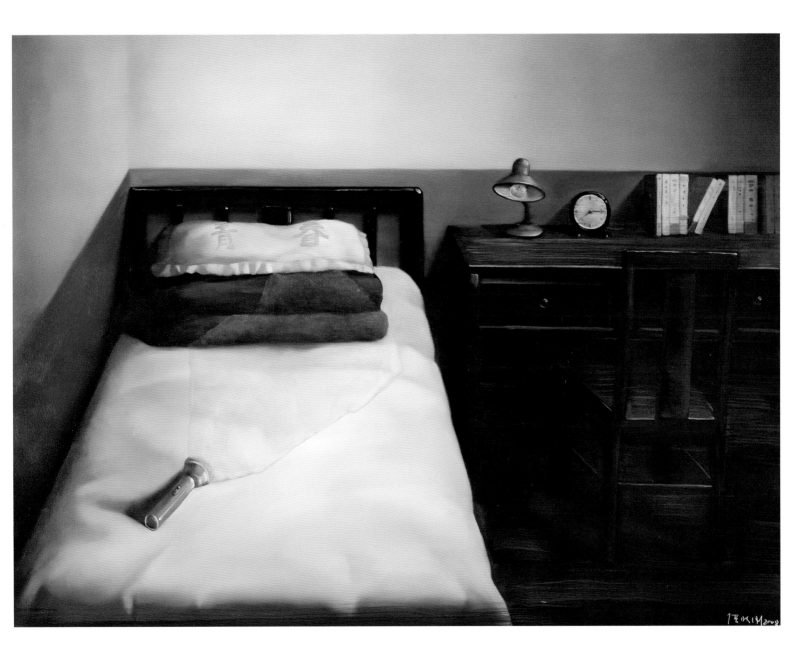

Green Wall - Wooden Bench

绿墙 - 长椅

2008

Oil on canvas
150 x 200 cm

布面油画
150 x 200 厘米

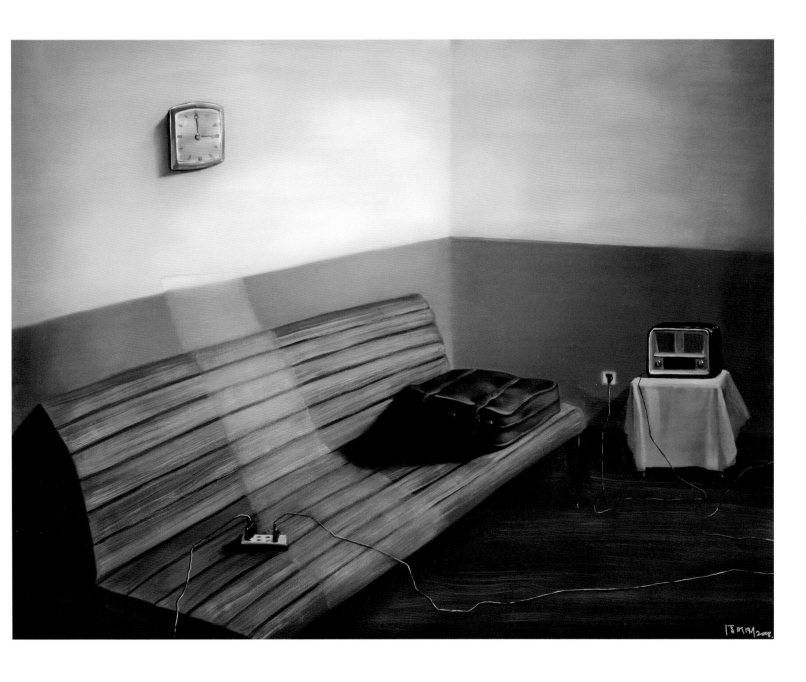

Green Wall - Slumber No.2

绿墙系列 - 关于睡眠之二

2008

Oil on canvas
160 x 200 cm

布面油画
160 x 200 厘米

绿墙系列 - 关于睡眠之二

Sleeping Boy on the Book

睡在书上的男孩

2008

Bronze
87 x 60 x 26 cm

铸铜
87 x 60 x 26 厘米

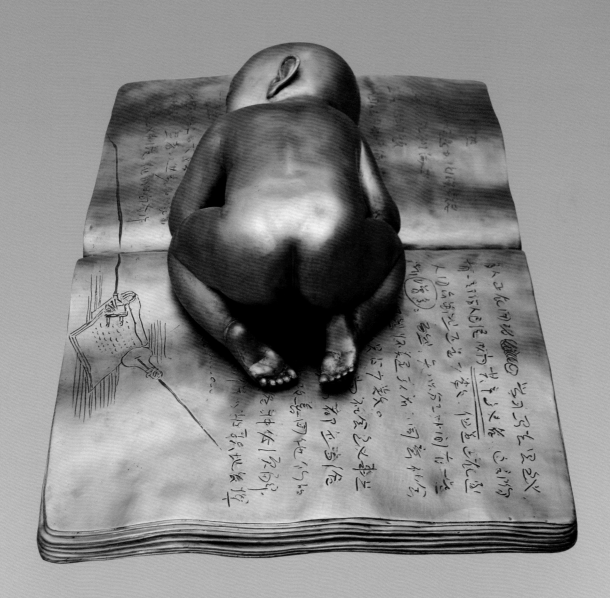

Sleeping Boy on the Crate

睡在箱子上的男孩

2008

Bronze
79 x 41 x 64 cm

铸铜
79 x 41 x 64 厘米

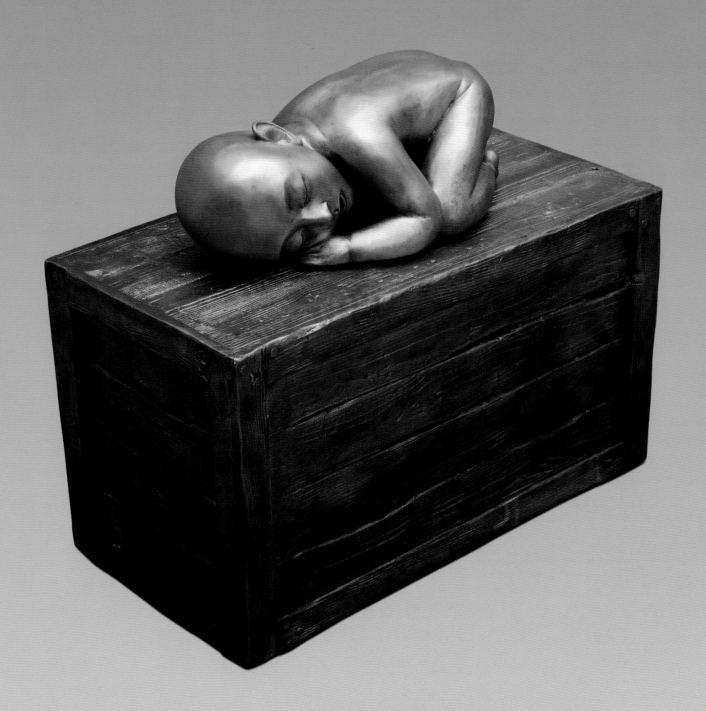

Sleeping Boy on the Bed

睡在床上的男孩

2008

Bronze and steel
108 x 59 x 111 cm

铸铜，钢
108 x 59 x 111 厘米

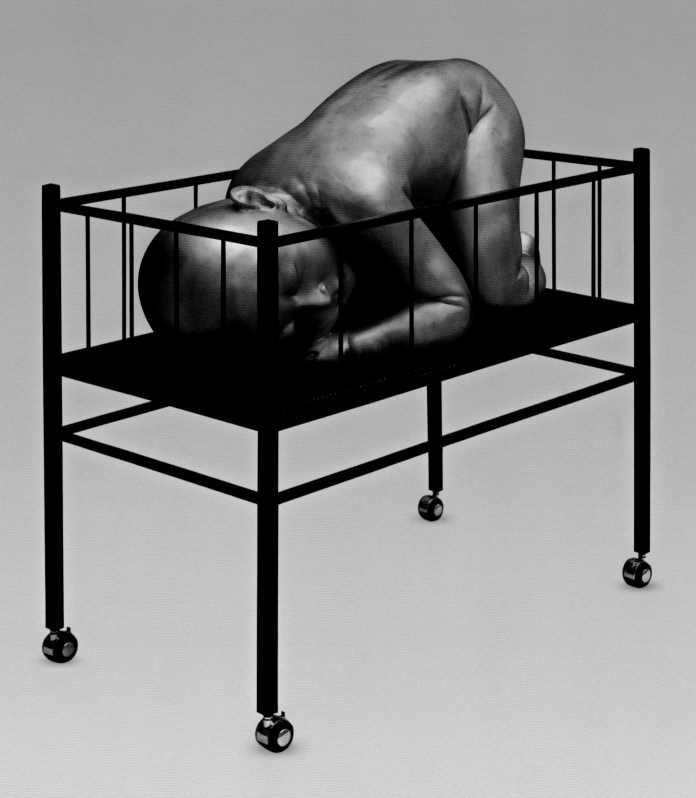

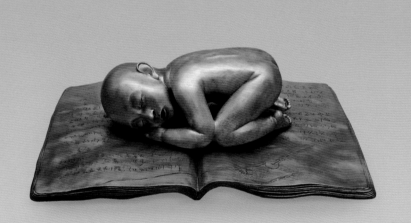
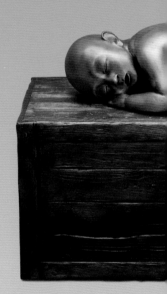

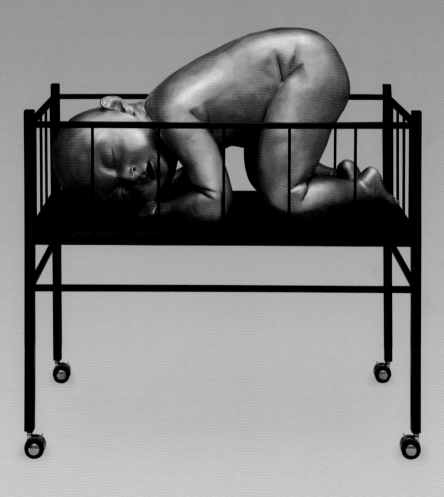

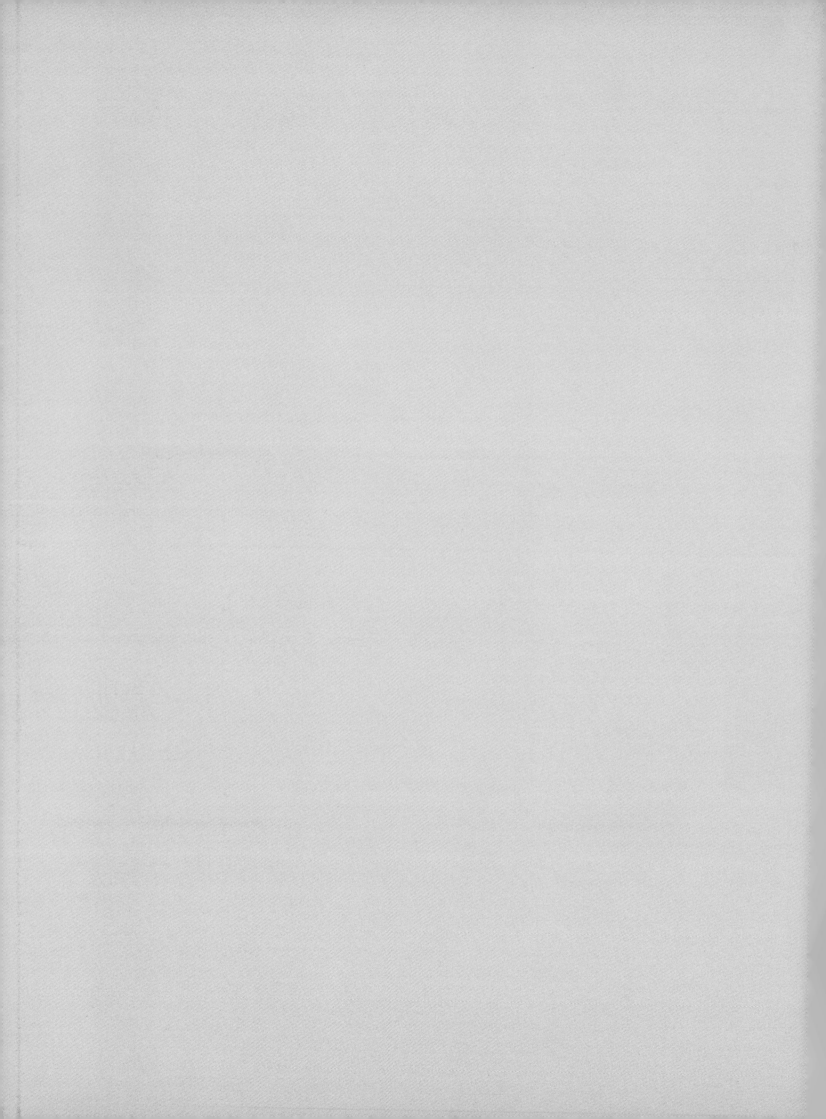

Sketches and Scripts
草图与手稿

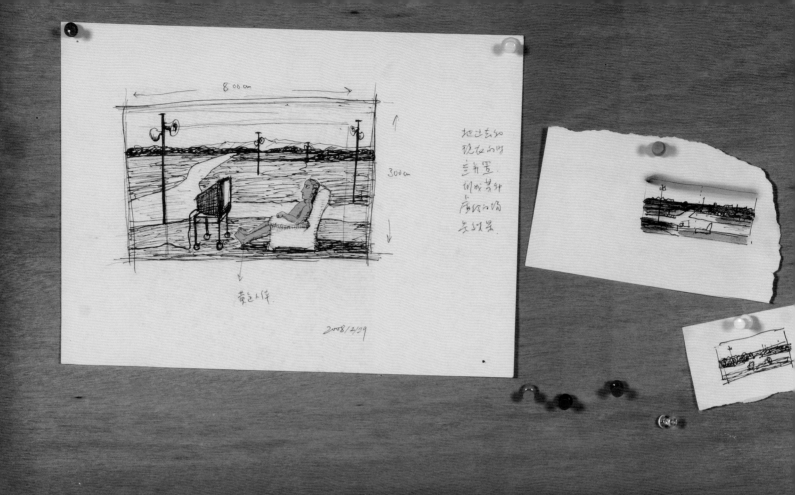

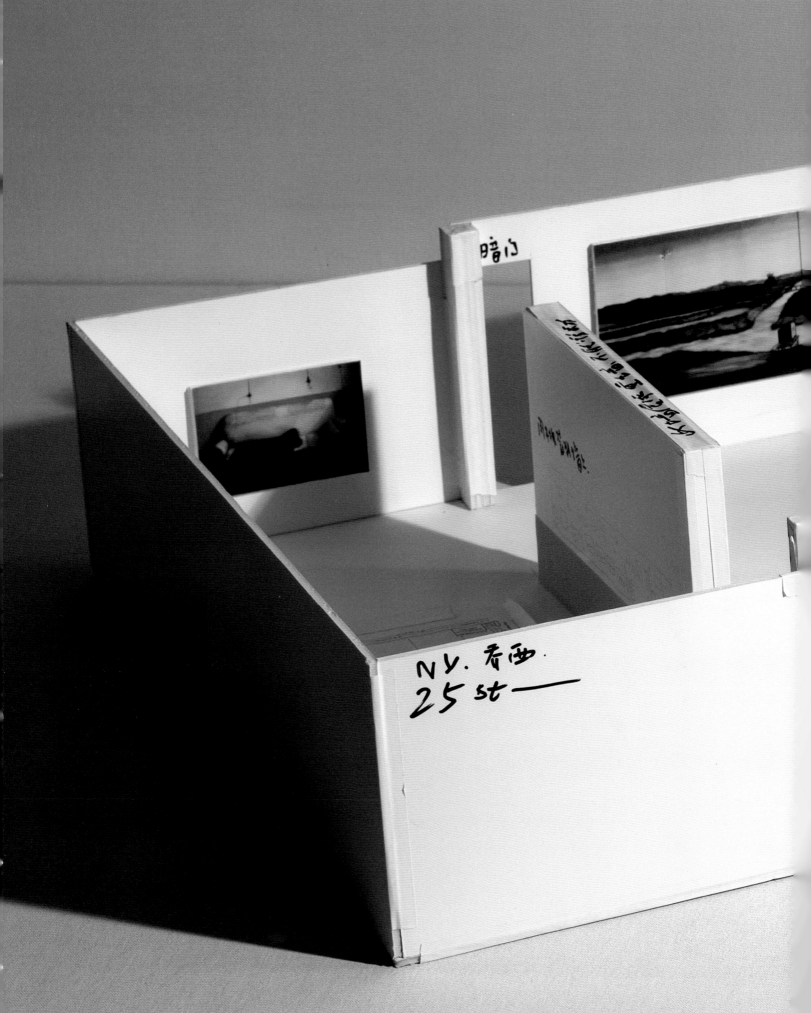

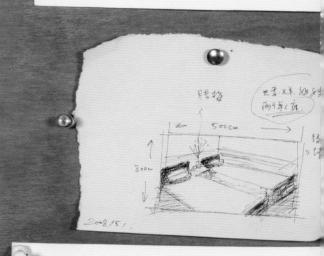

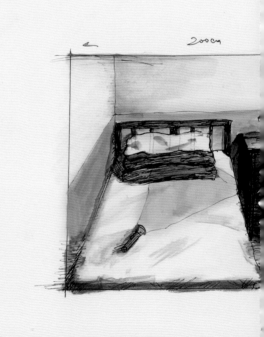

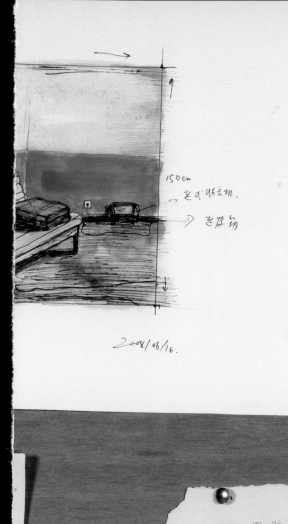

150cm
老式收音机.
老座钟

2008/06/16.

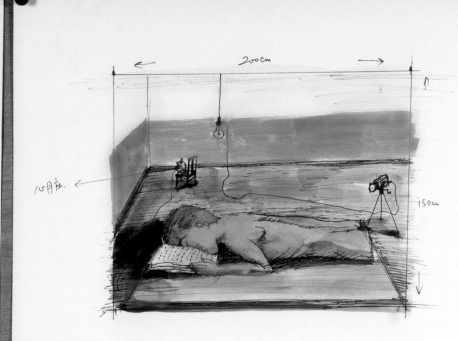

200cm

心月庄

150cm

2008/06/14.

一颗心月庄

灯:老吊灯

白色床单

2008/3/2

150cm

2008/06/14.

200

150

手电筒.

老箱子

200cm

150cm

手电筒. 旅行

150
200

看书的人.

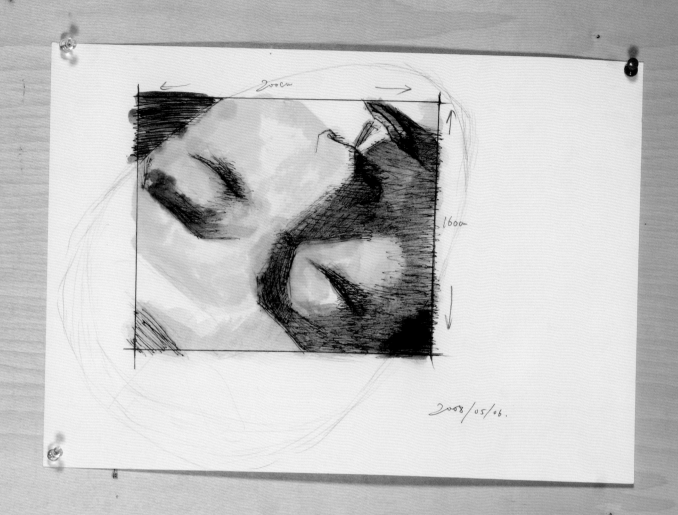

200cm

160cm

2008/05/06.

200cm

160 cm

2008/05/06.

Chronology
艺术年表

1958 – Born in Kunming

1963 – Moves to Sichuan province with his parents, where he spends most of his childhood. (63 Gulou North Third Street, Chengdu City, Sichuan Province)

1966 – The Cultural Revolution begins, the parents are isolated and under investigation, while the four children stop school and stay at home.

1973 – His parents receive Political rehabilitation from the government. He moves back again to Kunming with his parents.

1975 – He becomes a student of famous watercolor artist Lin Ling. He studies sketching, watercolor, and is introduced to Western ancient and modern art.

1976 – After High School, he is sent to Yunnan province through the Youth Re-education Program. (He is at the fifth team of Suoxi production brigade at Second Road Commune, located at Jinning County of Yunnan province.)

1978 – Enrolls in Sichuan Academy of Fine Arts in Chongqing. (He is accepted in 1977)

1980 – Due to the Open Door Policy, besides art from the former Soviet Union, he begins to gain access to a large number of information on Western art from the school library. He is interested in Western art, especially interested in van Gogh and Gauguin.

1981 – He spends two months living in the Aba Tibetan Autonomous Prefecture in Shichuan. When he returns to school, he starts a series titled *Prairie Group Painting*. This series is strongly influenced by van Gogh and Miller. However, because these paintings are very different from the "Local Realism" that is popular at the time, these works are not approved by the Academy's examination.

– The former editors of *Art* magazine, Li Xianting and Xia Hang, come to Sichuan Academy of Fine Arts. They give high recognition to *Prairie Group Painting*, and plan to introduce them in their magazine.

1977 in Yunnan
1977年，在云南

1982 – January, he graduates from Sichuan Academy of Fine Arts with a Bachelor degree.

– After graduation, he works at a glass and mirror factory and becomes a construction worker.

– Mid year, through a friend's recommendation, he starts working at Song and Dance Troupe of Kunming as an art designer.

– Five works on paper are included in British BBC World Painting Competition.

– *Prairie Group Painting* appears on the cover of Art magazine with an article by Xia Hang.

1983 – Starts exploring Western modern theory, philosophy and literature. Especially likes Existentialism, Absurd Drama and Surrealism, and admires Seventh Century Spanish artist, El Greco.

1984 – Hospitalized due to excessive drinking, he finishes *Between the Black and White Ghosts* drawing series in the hospital. Shortly after, he completes the series of *With the Specter of Color*. Meanwhile, he writes *Ghost Confession*. On October 12, he goes to work at Decorative Arts Company of Shenzhen University, later is fired and returns to Kunming.

1985 – He and other artists (Kunming artists: Mao Xuhui and Pan Dehai, Shanghai artists: Hou Wenyi and Zhang Long) organize self-funded traveling exhibition in Shanghai and Nanjing titled *As a New*. This exhibition is one of the earliest self-funded shows in the 85' Ideas movement, and is considered as one of the iconic event of the 85' Ideas.

– The work *Hill's Daughter* participates in the Course of Advancement of China's Youth – the National Youth Art Exhibition, which takes place in China Art Gallery.

1986 – With artists such as Mao Xunhui, Pan Dehai and Ye Yongqing he starts the Southwest Art Group. The second, third and fourth generations of *As a New* exhibition take place in Kunming Library and Sichuan Academy of Fine Arts among other locations.

– Completed *Exist for That* and *Searching for That Existence* essays. He begins to doubt "extreme individualism", which is popular at the time. Re-examines the influences of Western ideas to his life, he wants to use an in-depth and logical method in approaching various problems.

– October, he returns to Sichuan Academy of Fine Arts to become an instructor at the Education Department.

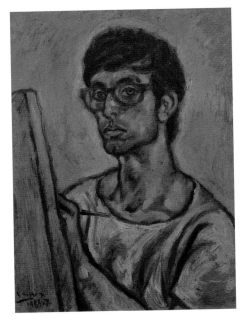

1983
Self-portrait
自画像

1984
The Ghost between Black and White,
No.10: Dialogue between Two Ghosts
黑白之间的幽灵10号: 两个幽灵的对话

– Becomes interested in Oriental Mysticism, Zen Buddhism and ancient Chinese paintings. He creates oil on paper *Lost Dreams* series.

1987 – Partial works from series *Lost Dreams* participate in the *Chinese Contemporary Artists of Four* group show, which is jointly organized by France-China Friendship Association and French government in Montpellier.

– *Hill's Daughter* participates in *Contemporary Chinese Oil Painting* exhibition in New York. It is organized by GHK Company and National Artists Association of China.

– Sichuan Fine Arts Publishing House publishes *Zhang Xiaogang Sketches Set.*

1988 – Marries Tang Lei

– Participates in the China Modern Art Forum at Huangshan, which is also known as the famous Huangshan Conference. At the meeting, *Ghost Series*

and *Lost Dreams* works are first shown via projection. It is his first time to meet many "New Wave artists" and "New Wave critics" from all over the world.

– Participates in organizing 1988 *Southwest Art* exhibition, which is hosted by Lv Peng.

– Reporter Zou Jianping writes a special column on him in Hunan Fine Arts Publishing House's *Painter.*

– Completes oil painting series *Interest-bearing Interest of Love.*

1989 – January, he goes to Beijing to participate in *China Modern Art* exhibition, which is hosted by Gao Minglu and Li Xianting. He experiences first hand the height of 85' New Wave movement and also its closing ceremony.

– April, his first solo exhibition takes place at Sichuan Academy of Fine Arts Exhibition Hall, featuring approximately thirty works from the *Lost Dreams* series. In that same afternoon, Chongqing student movement begins.

– December, reexamines various artistic problems or issues he faced in the past years.

1990 – Begins painting series *Black Triptych* and *Duplication of Space* among other works.

– Becomes extremely interested in the Magical Realism of Latin America. He especially likes Mexican female artist Frida Kahol.

– As a representative painter, his works are included in the *Chinese Oil Painting 1700 – 1985*, *Chinese Modern Art History 1979 – 1989*, and *100 Chinese Mainland Young and Middle-aged Generation Artists* publications.

1991 – Completes oil series such as *Notes* and *Set the Abyss* among other works.

– Work *Trilogy of Three Black*

– *Black Triptych: Depression* participates in I Don't Want to Play Cards with *Cézanne – Avant-garde Art* exhibition, sponsor by Asia-Pacific Museum of Arts in America, and the work becomes part of the museum's collection.

– Participates in Exhibition of *Contemporary Chinese Literature*, organizes by Wang Lin, a traveling exhibition which visits Beijing, Chongqing, Guangzhou, Nanjing among other cities.

1992 – June to October, he goes to Germany, the Netherlands, France among other places to study. It is his first time seeing so many Surrealist and Expressionist artworks. This experience causes him to reexamine his own artistic path with the hope of better understanding himself and his artistic values.

– Visits the 9th Kassel Documenta many times to better understand the developments of western contemporary art. He is greatly inspired by Gehard Richter's work. After this trip, he begins to reconceive his artistic development.

– October, he goes to Hong Kong to meet with Chang Tsong-zung of Hanart T Z Gallery to negotiate on possible collaboration.

– Participates in The 1990s Chinese Painting Art Biennale in and the works *Creation Chapter No. 1* and *Creation Chapter No. 2* receive Excellence Awards.

– December, he goes to Beijing to participate in The Second Session of China's Oil Painting Art Research Review meeting. In the meeting, The Ninth Kassel Document Show is being introduced.

1993 – Participates in 89 China's New Art Exhibition is organized by Hong Kong Arts Center and HanartTZ. It is hosted by Li Xianting.

1990
Black Triptych Fear, Mediation and Depression
黑色三部曲之一恐怖，之二冥想，之三忧郁

1991
A Week Note No.4
一周手记之四

– Participates in *Mao Goes Pop-China – after 89 New Chinese Art* exhibition at Sydney Modern Art Museum, Australia.

– He goes back to Kunming, starts some portrait experimentation.

– He feels touched while flipping through his parent's old photographs, reexamines his artistic developments in the past two years, and starts exploring new artistic creations.

– December, Wang Lin organizes *90 Years of Chinese Art – China Experience* exhibition at Chengdu Museum of Art. The earliest works of the *Big Family* series are first exhibited in this show.

– *Quanjiafu* is first exhibited in *89' China's New Art* exhibition at the Marlbrough Gallery in London. This work is in the personal collection of the director of Fukuoka Art Museum.

1994 – April, *Big Family* series is developed, formenting a new artistic style.

– July, completes four works of *Big Family* series. These works, entitled *Bloodline: Big Family* earns him an invitation to participate in The 22nd Brazil Biennale at Sao Paulo, where he receives third place.

– July 28 , his daughter Huan Huan is born.

1995 – Work is used for the French version of *Life* cover.

– February, he receives invitation to participate at the Venice Biennale.

– February to May, he creates the works to be presented at Venice Biennale in Chongqing, where he completes thirteen of the *Big Family* series.

– July, he goes to Venice Biennale, he has three large scale works on display, entitled *Bloodline: Big Family.* One of the works is collected by famous American director Oliver Stone.

– During Venice Biennale, he is invited by the Guggenheim Museum to attend a dinner party at the Palais des Craciunescu, and meets the late Princess Diana in person.

– He is invited to participate in *Chinese Avant-garde Art 15 Years* exhibition at Barcelona Museum of Modern Art in Spain. Three works in *Big Family* series are on displayed.

– Visites Tapies's studio and art center in Spain.

– Two works participate from the *National Consciousness – State Run Away – China's New Art* exhibition at Hamburg International Avant-garde Cultural Center, Germany. The show is curated by Li Xianting.

– October, he accepts interview by German Third Television Station.

– Work *Bloodline: Three Comrades* is used on the poster of the International Arts Festival in Paris.

– Works participate in *New Chinese Art* exhibition at Vancouver Art Gallery.

– Work *Mother and Son* becomes part of Fukuoka Art Museum's collection.

1996 – Moves to Chengdu. (No.5 Shazi Yandong lane Yulin Disctrict)

– Participates in *China!* exhibition, which is organized by Contemporary Art Museum in Bonn, Germany, featuring three works from *Big Family.*

– Attends a lecture conference organizes by German Foreign Affair and Cultural Department, also accepts interviews by various European media.

– March, attends *Share the Dream – Five Chinese Contemporary Artists Group Show* at Jamaica Arts Center in New York. He accepts interviews by various New York television stations. While he is in New York, he goes to many famous Contemporary art galleries.

– June, participates in the Edinburgh Festival, six works at the Fruitmarket Gallery's *Reckoning with the Past – Contemporary Chinese Paintings* exhibition.

– Fall, three works exhibite at the Asia Pacific Triennial of Contemporary Art at Queensland Museum. One of the works joins the Queensland Museum's collection.

– Five works participate in *1996 – Four Artists from China* exhibition in Paris, France.

– Participates in *Reality: Today and Tomorrow – 96 Chinese Contemporary Art* at Beijing International Yi Yuan Art Gallery, organizes by Leng Lin.

– December, participates in the *Inaugural Academic Exhibition of Contemporary Art*, jointly organized by National Art Museum of China and Hong Kong Arts Center, and receives Cultural Award. It is hosted by Huang Zhuan.

– An article on the dialog between him and Huang Zhuan is published in *Gallery* magazine, he elaborates on his artistic point of view and style. The article is titled "Status Judgment and Cultural Experience".

1997 – March, receives New Contemporary Asian Art Prize from the British Coutt's International Contemporary Art Foundation in Hong Kong. He also accepts interviews by various Hong Kong newspapers.

– Works participate in *Arch – Gate* exhibition in Spain.

– June, participates in *Red and Gray – Eight China's Avant-garde Artists* exhibition at Simin International Yi Yuan Gallery. He also participates in Singapore Art Museum's *From the Face and Body – New Chinese Art* exhibition.

– Work *Quanjiafu* joins Okinawa museum's collection.

– Work *Bloodline: Big Family* joins Hong Kong International Conference Center Collection.

– Fall, 12 works participate in *From the Face and Body*

– *the New Art* exhibition, which is organized by the Museum of Fine Arts in Prague.

– Work *Siblings* participates in *100 Years of Chinese Oil Painting Portraits* exhibition at China Art Gallery.

– Participates in *8+8-1 – 15 Chinese Contemporary Artists* exhibition at Schoeni Gallery in Hong Kong, featuring 60 small works.

– Six works participate at Portugal, *15 Chinese Contemporary Artists* exhibition sponsor by Lisbon Association.

– Work *Quanjiafu* joins the Netherlands Peter Stuyvesant Foundation's collection, and participats in Collection of International Contemporary Art exhibition hosts by such foundation.

– Proposes to stop teaching position at Sichuan Academy of Fine Arts. He leaves the school and gave up teaching.

– December, is invited by The Central Academy of Fine Arts to hold a solo exhibition *1997 Family*, featuring 10 works.

– At 55 Yulin West Road, Chengdu Tang Lei opens Small Pub. Small Pub becomes a meeting spot for artists from all over and famous for its promotion of Chengdu music.

1998 – Hanart T Z Gallery holds a show *Bloodline: Big Family* in Taipei.

– Five works participate in *New Chinese Art* exhibition at Helsinki Museum of Fine Art in Finland.

– Participates in *Magritte and Contemporary Art* exhibition, which is to commemorate Magritte at the D'ostende Contemporary Art Museum. Writes an accompany essay for the exhibition "Magritte and I".

– Work *Brothers and Sisters* joins the collection of River Museum in Chengdu. Also assists the museum collections and exhibitions of contemporary art in China.

– One work from *Family* series joins the Netherlands' Peter Stuyvesant foundation collection, and participates at *The International Contemporary Art* exhibition that takes place at Amsterdam.

– Involves in the planning of *Vision of Power* exhibition at River Museum of Chengdu.

1999 – Invited to Paris, France to participate in *Comrades* exhibition, where 15 of new works are included.

– Li Xianting writes the preface for *Contemporary Chinese Art of Miniature-artists Zhang Xiaogang and his portrait miniature of the Chinese People* exhibition. It's the first time for such gallery to host a contemporary exhibition after introducing artist Zao Wou-ki in the 1970s.

– Two works participate in 1999 *Chinese Contemporary Art* exhibition at LIMN Gallery in San Francisco in the United States.

– Participates in *Faces – International Contemporary Art* exhibition at Namur Art Center in Belgium.

– Work *Three Children* joins the collection of Dongyu Museum at Shenyang Province, and participates at the Museum's *The First Session of China's Contemporary Art Collection Exhibition: Open Access.*

– Work *Quanjiafu* participates *Inside Out: New Chinese Art* exhibition curated by Gao Minglu and sponsored by New York P.S.1 Contemporary Art Center and San Francisco Museum of Contemporary Art.

– Works included in American publication *The World*

of Contemporary Art History.

– July, separates with wife, Tang Lei, after ten years of marriage.

– July to September, stays in Kunming and Dali. Creates some small works of ink on paper.

– October, moves to Beijing. (Building 116 Huajiadi Xili)

2000 – January, participates in *Held the Door of the Century – the Invitation of Chinese Art* exhibition at Chengdu Museum of Modern Art. Work *Sister and Brother* joins the British GASWORKS Art Foundation collection.

– March, participates in *Man+SPACE: the third Gwangju International Contemporary Art Biennale* exhibition at South Korea, features 6 works of art.

– Works included in a British publication *Chinese Art History.*

1995
Bioodline: Big Family No.2
血缘：大家庭 No.2

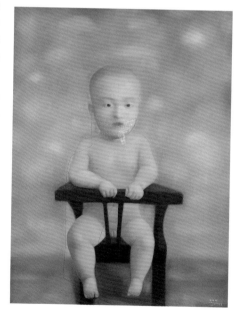

1998
Yellow Baby
黄色婴儿

– Two works included in *Beyond Shackles* exhibition at Montclair University Art Museum in the United States.

– June, participates in *Portrait of Contemporary China* exhibits at Mitterrand National Cultural Center in Perigueux, France. Meets and exchanges with French artists, also visits Biennale Lyon, France.

– Work *Portrait of Girl* joins the Shanghai Art Museum collection, and participates in the museum's first *Chinese Contemporary Art Collecion* exhibition.

– Work *Big Family 1997* participates in *100 Years of Chinese Oil Paintings* exhibition at National Art Museum of China in Beijing.

– Work included in *Asian Contemporary Art* exhibition at the New Soup County Hall, sponsored by Utsunomiya Museum.

– July to August, creates new works at Chengdu studio.

– Works being included in to the publication *China's*

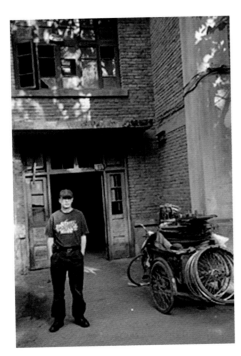

1998 in Kunming, background is Kunming City Song and Dance Troupe, 1982-1986 was an artistic set designer
1998年于昆明，背景是昆明市歌舞团，
1982-1986曾在此作舞美

Contemporary Art History 1989-1999, Hunan Fine Arts Publishing House.

– October, *Zhang Xiaogang 2000* at Max Protech Gallery in New York.

– November, participates in *Chinese Contemporary Art* exhibition at the National Museum, work *Comrades* is in the museum's collection, while *Brother and Sister*, and *Girl* are in Swiss collector Dr. Daniel's collection.

2001 – Holds offices as a job-waiting employee at The Sichuan Academy of Fine Arts, as it goes through a structural reform.

– *It's Me, It's Us* exhibition, Gallery of France, Paris, France.

– Accepts interview at studio in Beijing by Hunan Television Station.

– Goes to Changsha to participate Hunan Television Station's Anniversary celebration, presents a huge work with artists Wang Guanyi, Fang Lijun and Yue Minjun.

– Accepts interview by CNN in Beijing studio.

– Four works participate *New Image – 20 Years of Chinese Contemporary Art*, an exhibition organized by National Art Museum of China travelling to Shanghai Art Museum, Sichuan Museum of Fine Arts, and Guangdong Museum of Art.

– Two works participate in *Hot Pot – Chinese Contemporary Art* exhibition in Oslo, Norway.

– Summer, collaborates with Ye Yongqing to start Kunming Warehouse Art Space.

– Four works participate at the third Mercosul Biennial in Brazil.

– October, participates in *Dream – 2001 Contemporary Chinese Art* at the Red Mansion Foundation in London.

– November, goes to South Korea to conduct cultural and academic exchange.

– December, participates at the first Chengdu Bienniale organized by Chengdu Museum of Modern Art. Exhibition work *Tongue Boy* is collected by New South Wales Art Gallery in Sydney, Australia.

2002 – Four works participate in *Made in China – 14 Chinese Contemporary Artists* exhibition, which is co-sponsored by Enrico Navarra Gallery in paris and Hanart T Z Gallery in Hong Kong.

– Work *Sleeping Infant* participates in BABEL 2002 organized by Korea National Museum of Contemporary Art in Seoul.

– Agrees to work with Kwai Fung Hin Gallery in Hong Kong to collaborate on print project in France.

– May, participates in the exhibition and lecture of *Review 77', 78'* exhibition at Sichuan Academy of Art Museum, and also participates in the Part of *Beijing Artists Working State* roundtable discussion.

– June, participates in *A Point in Time – in Changsha* exhibition organizes by Chansha Meilun Museum of Art.

– July, starts creating the *Documents* series.

– August, works from *Documents* series included in *Long March,* a thematic exhibition curate by Qiu Zhijie and Lu Jie.

– Works included in Chinese Art Tiennale at Nanjing Museum, *Contemporary Chinese Oil Painting* exhibition at Shenzhen Museum, and Guangzhou Triennale at Guangzhou Museum of Art.

– Work included in *Chinese Contemporary Art* Exhibition in Duisburg, Germany.

– Participates in *Paris, Beijing – Ullens Collection* Exhibition in Paris.

– September, participates with Wang Guanyi in Non-Senanayake Expo Opening Ceremony in Paris, also supervises over print making production.

– November, *Image is Power – Wang Guangyi, Zhang Xiaogang, Fang Lijun,* a historically significant exhibition at He Xiangning Art Museum in Shenzhen.

– Starts *Amnesia and Memory* series.

2003 – Beginning of the year, starts building new studio in Cui Ge Zhuang, Beijing.

– Work participates in *From China with Art* exhibition, organzied by the Indonesia National Gallery.

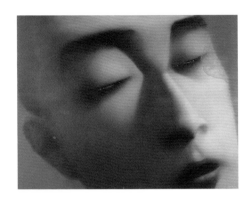

2003
Amnesia and Memory No.1
失忆与记忆 No.1

– Spring, work *Amnesia and Memory* participates in *China – 3 Faces 3 Colors* exhibition at Artside Gallery in Seoul, South Korea.

– April, stays in Chengdu during SARS and writes article "The Letter to Friends", which discusses the concepts and ideas behind series *Amnesia and Memory*.

– May, stays in Kunming and set up a studio on Xiba Yongle Road. Paints the outter walls of Studio black to commemorate on the scenery of the North.

– June, participates in *Amnesia and Memory* exhibition at Gallery of France in Paris, which features about 15 works. Meanwhile, one work participates in *The East Daybreak – 100 Years of Chinese Painting* exhibition in African Museum, Paris.

– Fall, returns to Beijing. Participates in *Open Sky – Contemporary Art* exhibition in Shanghai Duolun Museum of Modern Art.

2004 – January, participates in *China Now* exhibition at Tang Gallery in Bangkok, Thailand with work *Girl*.

– Spring, participates *Beyond Boundaries*, an inaugural exhibition at Shanghai Gallery of Art curates by Weng Ling.

– April, has his first solo exhibition at Hong Kong Arts Center curates by Chang Tsong-zung. It features 50 works from 1988 to 2004. Hanart T Z Gallery

organizes the catalogue titled *The Umbilical Cord of Time – Zhang Xiaogang's Paintings*. Gives lectures and discussions on his inner artistic growth and journey during the exhibition period, and accepts interviews by Hong Kong media.

– Four works from *Amnesia and Memory* series participate the fifth Shanghai Biennale at Shanghai Art Museum.

– Work participates in *Face to Face* at Accor Gallery in Taipei.

– Two works participate in *Body China* exhibition at Marseille Museum of Art in France. Works join the collection of famous French musician Yaer, and he uses them in his performance in China as the artistic visual material.

– Fall, works from *Amnesia and Memory – a Week Diary* series participate along with works by Wang Guangyi and Zeng Hao in *Three Worlds* exhibition at Third on the Bund, Shanghai Gallery of Art. This show is curated by Weng Ling.

– Participates in *The First Wuhan Fine Arts Archive Nomination* exhibition at Hubei Academy of Fine Arts Museum, receives a prize.

– Starts a huge work *Big Family – Subway* for OCT Contemporary Art Center in Shenzhen.

2003
Amnesia and Memory No.8
失忆与记忆 No.8

2005 – Work he makes for Shenzhen Metro opening *Big Family – Subway* participates in *Take-off – OCAT Contemporary Collection* exhibition at the OCAT Contemporary Art Center in Shenzhen. The show is curated by Huang Zhuan. Meanwhile, participates in exhibition symposium. Later, this work joins the He Xiangning Art Museum collection. Its original plan to display at the Shenzhen subway station is postponed.

– During Spring Festival, goes on a trip to Yunnan with friends to do landscape sketchings to prepare for future series.

– March, Director Zhang Yang uses *Big Fmily* series in his film *Sunflower*.

– April, *Amnesia and Memory* solo exhibition at Max Protetch Gallery in New York. This show is curated by Leng Lin. He accepts interviews by the media. While staying in New York, he visits Chelsea District, Accor Museum of Fine Arts, MoMA, and familiarise with the development of New York contemporary art galleries. Also, has academic exchange with Taiwanese artists staying in America.

– The end of April, participates in *Always to the Front – Chinese Contemporary Art* exhibition in Kuandu Museum of Fine Arts in Taiwan. It's the artist's first visit to Taiwan, and stays overnight at Sun Moon Lake.

– June, accepts interview by The *New York Times* in Beijing studio.

– July, goes to Kunming. Starts new photo series *Written Memory*, later renamed *Description* series.

– August, accepts interview by CCTV interview.

– September, returns to Beijing. Participates in *Plato and His Seven Spirits – Contemporary Art* exihibition, which is curated by Huang Zhuan and exhibites at Beijing OCAT Contemporary Art Center. The show features works in *Description* series.

– Photo series *Description* participates in *Allegory* exhibition in Hangzhou, is curated Gao Shiming. Due to a problem at the exhibition site, half of the works exhibited are destroyed.

– Fall, works participate in Guangzhou Triennale at Guangdong Art Museum.

– Early October, starts to prepare for new series *In-Out – on the Socialist New Scenery and a Family Environment*. Meanwhile, discusses the plan of exhibiting these new works at curator Leng Lin's Beijing Commune Gallery space.

– November, participates in *The Sky – 2005 Fate Chinese Contemporary Art Shelves* (Painting) exhibition in Shenzhen Art Museum, which is curated by Ye Yongqing. In Shenzhen, writes the catalogue essay, "The Da Mao I know", for artist Mao Xunhui's solo exhibition. In this process, remembers much about the time living and creating with friends such as Mao in Kunming back in the 1980s.

– November, moves Beijing studio to Jiuchang Art District next to Beihuqu Bridge in Wangjing. Paints the outter walls yellow to commemorate Yunnan.

– Works participate in *Big River – New Period of Chinese Oil Painting and Retrospective* exhibition at the National Art Museum of China.

– Two works from series *Amnesia and Memory* participate in the inaugural exhibition of Arario Gallery in Beijing *China, Germany: Contemporary Artists Group Show*.

– End of the year, two works *Amesia and Memory* and *Notes* participate in *Contemporary Visual – an Exhibition for the Collectors – First Chinese Contemporary Art Annual* exhibition at China Millennium Monument Art Museum, curated by Fan Di'an.

2006 – January, returns to Kunming. Starts new series *In-Out – on the Socialist New Scenery and a Family Environment*.

– April, solo exhibition *Home* at Leng Lin's Beijing Commune Gallery space, features 12 works from series *In-Out* as well as 10 works from photo series *Description – Heroic Sons and Daughters*.

– Huang Zhuan again holds exhibition *Plato and His Seven Spirits* at Shenzhen OCT Contemporary Art Center, features 20 photo works. Later, same works participate in *Jiang Hu – Chinese Contemporary*

Art Enruopean and American traveling exhibition, a Chinese artists group show in New York.

– Photo series *Description* participates in *Reinventing Books in Chinese Contemporary Art* exhibition at China and the United States Association of Art Museum in New York.

– Late April, the Sichuan Academy of Fine Arts establishes "Zhang Xiaogang Art Studio" to encourage young students.

– Early May, supervises the creation process of prints in South Korea, also accepts interviews by local media.

– June, the Shenzhen subway station hosts a ceremonial reception to welcome the work *Big Family – Subway*, which is part of He Xiangning Art Museum's collection, being hung in its station.

– Early July, has his first solo exhibition *Zhang Xiaogang* in Japan. The exhibition takes place in Wonder Site Shibuya Arts Center. Also, accepts interviews by various media sources in Japan.

– Late July, accompanies his daughter to Thailand on vacation, at the same time creates oils on paper works.

– August to Septermber, accepts interviews by American and French media.

– Donates work *Girl* to Asian Art Archive in Hong Kong.

– Fall, works *Amnesia and Memory* and *Big Family*

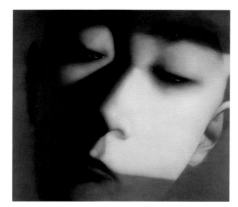

2004
Amnesia and Memory No.6
失忆与记忆 No.6

participate in *China Now – Fascination of A Changing World* exhibition, curates by Feng Bo at Sammlung Essl Museum in Vienna.

– October, work *Father and Daughter* participates in *The Blossoming of Realism – The Oil Painting from from Mainland China since 1978* exhibition, jointly sponsor by the National Art Museum of China and Taipei Fine Arts Museum.

– November, has his first solo exhibition in South Korea. The exhibition features four works of oil on canvas, seven works on paper and prints at ArtSide Gallery in Seoul. Also accepts interviews by various local media.

– Prepares for a solo exhibition in 2007, starts new sculptural series.

– December 25th, hosts his engagement reception with Jia Jia in Shanghai, Zeng Hao and Chen Wen engage at the same time.

– End of the year, accepts interview by British and French media.

2007 – January 12th marries Jia Jia in Shenzhen.

– Returns to Beijing and starts to create sculptural model.

– January, works of print participate in *New Southwest Contemporary Painting* exhibition at K Gallery in Chengdu.

– February, accompanies daughter to Kunming on vacation.

– March, participates in *Shanghai·Now* inaugural exhibition of Art Now Gallery in Shanghai.

– Works on paper participates in *Zhi Shang Tan Bing* exhibition at Nanjing Quartet Art Museum.

– April, participates Guiyang Biennale, also participates *Chinese Society Art* exhibition in Moscow, Russia.

– Participates in *From the Southwest – Southwest Contemporary Art* exhibition at Guangdong Museum of Fine Arts.

– Meets with PaceWildenstein Gallery from New York.

– July, work *Quanjiafu* participates in *Black, White and Grey – a Pro-active Cultural Choice* exhibition,

curates by Gao Ling at Beijing Today Art Museum.

– The interview with Yang Lan in Beijing Jiuchang studio goes on air in CNN's Talk Asia.

– Returns to Yunnan and creates two sets of *Discription* series.

–September, solo exhibition *Zhang Xiaogang* opens at Tampere Hilton in Finland. The same month, work *Lovers* participates in *Open China Art* exhibition, organises by National Art Museum of Art at The Russian State Museum in St. Petersburg.

– Starts to create print works.

– October, attends *Personal History* symposium, invited by professor Jonathan Fineberg of University of Illinois Urbana-Champagne.

– October, fourteen photo works *Description 2007* participate in *China – Facing Reality* exhibition organises by National Art Museum of China at Museum Moderner Kunst Stiftung Ludvig in Vienna, Austria.

– November, works in the 1980s *Ghosts* and *Lost Dreams* participate in *85 New Wave: The Birth of Chinese Contemporary Art* at UCCA Beijing. Also gives lecture in UCCA on November 24th.

– Donates work *Colorful Tiananmen* to Asia Art Archive in Hong Kong.

– Moves to new studio in Hegezhuang, Beijing.

– December 10th, art studios, which are named after the artist along with Wang Guangyi, Fang Lijun and Yue Minjun are completed at Chongqing Tanks for the Arts Center. They are invited back to Sichuan Academy of Fine Arts as professors.

2008 – January 2nd, accepts interview by Singapore media. Also starts preparing for *Slumber* series, which is part of the *Revision* series.

– February, meets with Nedoma, Director from Prague Art Museum, and curator Chang Tsong-zung to discuss future exhibition in Prague. Also, starts creating *Green Wall* series.

– March, accepts interview by news media, The Guradian from England and Asahi Shimbun from Japan.

– May 12th, Sichuan Wenchuan 8.0 earth quake.

– Donates work *Father and Daughter* to charity auction. All proceed goes to The Red Cross Society of China.

– May, accepts interview by Canadian television station and *Architectural Digest Espana* from Spain.

1958 – 出生于昆明。

1963 – 随父母移居四川省成都市鼓楼北三街63号，在那里渡过童年和少年。

1966 – 文化大革命开始，父母均被隔离审查，与兄弟四人停学在家。

1973 – 父母获平反，随父母再次移居昆明。

1975 – 拜云南著名水彩画家林聆先生为师，研习素描、水彩。在林先生家开始阅读、接触西方古代艺术史和西方现代艺术史。

1976 – 高中毕业后，下乡插队至云南省晋宁县二街公社锁溪大队五小队。

1978 – 考入重庆四川美术学院绘画系油画专业七七级。

1980 – 随着改革开放，开始在学校图书馆里接触到苏派艺术之外的大量西方艺术。并对西方现代艺术产生兴趣，尤对梵高、高更极其推崇。

1981 – 在四川阿坝藏族地区体验生活近两个月，回到学

1958 one-hundred-day commemorate photograph
1958年，百天纪念照

校开始创作毕业作品油画系列《草原组画》。

– 画风受梵高和米勒影响，由于这批作品与当时盛行的"乡土现实主义"趣味不符，未通过学院审查。

– 《美术》杂志前执行编辑栗宪庭、夏航来四川美院组稿，对《草原组画》予以充分肯定，准备在刊物上重点介绍。

1982 – 大学毕业，获学士学位。

– 毕业后因无法分配到工作单位，去一家集体所有制单位玻璃制镜厂打工，做建筑工人。

– 年中，经朋友引荐，进入昆明市歌舞团任美工。纸上作品五幅参加英国BBC公司举办的《世界绘画大奖赛》。

– 《美术》杂志以重点版面发表《草原组画》，夏航先生撰文评介。

1983 – 开始研究西方现代艺术理论、西方现代哲学、文学。对存在主义哲学，荒诞派戏剧及超现实主义的理论和作品尤感兴趣，特别推崇十七世纪西班牙艺术家埃尔·格列柯。

1984 – 因喝酒过量住院，在医院中创作完成素描集《黑白之间的幽灵》。出院后，随之创作完成油画系列《充满色彩的幽灵》，同时写有《幽灵自白》等文。

– 10月至12月，去深圳大学艺术装饰公司打工，后被公司炒鱿鱼，回到昆明。

1985 – 与昆明的毛旭辉、潘德海，上海的候文怡、张隆等在上海、南京自费办展，取名《新具像》。此展为85'思潮中最早自筹办展的展览之一，并被称为85'思潮中的代表性艺术倾向之一。

– 作品《山的女儿》参加中国美术馆《前进中的中国青年——全国青年美展》。

1986 – 与毛旭辉、潘德海、叶永青等人在昆明共同创立"西南艺术群体"。并在昆明图书馆、重庆四川美院等地分别举办了《新具像》第二、三四届作品及图片展。

完成《为了那个存在》、《寻找那个存在》等随笔论文。对当时盛行的"极端的个人主义"，开始产生怀疑。重新整理西方现代主义对自己的种种影响，向往以某种理性和深入的艺术思维方式来面对种种问题。

– 10月调回四川美术学院师范系执教。

对东方神秘主义，禅宗思想及中国古代绘画等产生兴趣，开始创作纸上油画系列《遗梦集》。

1987 – 《遗梦集》部份作品参加法中文化友协与法国蒙彼利埃市政厅联合举办的《中国当代艺术家四人展》。

– 作品《山的女儿》参加美国GHK公司和中国美协在纽约联合举办的《中国当代油画展》。

– 由四川美术出版社编辑的《张晓刚速写集》出版。

1988 – 与唐蕾结婚

– 参加在黄山举行的《中国现代艺术研讨会》即后来称之为的著名的"黄山会议"，在会上放了《幽灵系列》、《遗梦集》幻灯。同时第一次结识了来自全国各地"新潮艺术家"及"新潮批评家"。

– 参与筹划由吕澎主持的《88西南艺术》展。

– 湖南美术出版社《画家》专栏介绍，邹建平著文专记。

– 完成 油画组画《生生息息的爱》。

1989 – 元月赴北京参加由高名潞，栗宪庭等人主持的《中国现代艺术大展》——中国美术馆。亲自目睹了中国85'，新潮运动的高峰和结束仪式。

– 4月在四川美术学院阵列馆举办首次个展。共展出纸上油画系列《遗梦集》三十余幅。展览开幕后的当天下午，重庆的学潮开始。

– 11月应西班牙使馆文化处激请赴京举办个展，后因故停展。

– 12月重新开始审视自己几年来的艺术创作等问题。

1990 – 开始创作组画《黑色三部曲》、《重复的空间》等作品。

– 对拉丁美洲的魔幻现实主义的文学作品十分迷恋。尤其喜爱墨西哥女画家弗里达·卡洛的作品。

– 作为代表画家被收入《中国油画1700——1985》、《中国现代艺术史1979——1989》、《中国大陆中青年代美术家百人传》等书中。

1991 – 创作完成油画系列《手记》、《深渊集》等作品。

–《黑色三部曲之三——"忧郁"》参加美国亚太艺术博物馆主办的《我不与塞尚玩牌——中国前卫艺术展》，作品被该博物馆收藏。

– 参加王林主持的《中国当代文献资料展》，并在北京、重庆、广州、南京等地巡展。

1992 – 6月至10月赴德国、荷兰、法国等地学术考察。第一次大量面对表现主义和超现实主义的作品，反审自己的艺术历程及个人气质，再次寻求自我的价值判断及学术定位。

– 反复观摩第九届卡塞尔文献大展，尽可能多地去了解西方当代艺术的发展和现状，在德国当代艺术家里希特的作品中受到启发，尤其在自己的学术清理上起到极积作用。初步确立了自己未来艺术的发展方向。

– 10月到香港，与汉雅轩负责人张颂仁合谈有关合作的可能性。

– 参加由吕彭主持的广州《九十年代中国美术油画双年展》、参展作品《创世篇》No. 1，No. 2获优秀奖。

– 12月赴北京参加《第二届中国油画艺术研究讨会》，会上以幻灯讲座介绍第九届卡塞尔文献展。

1993 – 参加由栗宪庭主持，香港艺术中心与汉雅轩联合举办的《后89中国新艺术大展》。

– 与香港汉雅轩画廊签约，成为该画廊的代理画家。

– 作品参加澳洲悉尼当代美术馆《"毛"——走向波普——后89中国新艺术》。

– 夏天回到昆明，开始做一些肖像画的实验。

1984
New Born Spirit
初生的灵魂

– 偶然翻看父母的老照片，受到触动，结合近两年在艺术上的反思，开始探索新绘画作品。

– 12月在成都美术馆，参加由王林主持的《九十年中国美术—中国经验》展，展览中首次展出《大家庭》组画的初期作品。

– 作品参加在伦敦Marlbrough 画廊举办的《后89中国新艺术》，此展览展出了第一幅《全家福》，此画被福冈美术馆馆长收藏。

1994 – 4月完成《大家庭》组画的艺术倾向定位。

– 7月创作完成四幅《大家庭》组画作品，携这四幅作品应邀参加巴西《第22届圣保罗双年展》，作品取名《血缘——大家庭》。此组作品在该展获铜质奖。

– 7月28日女儿欢欢出生。

1995 – 作品被用作法文版《活着》封面。

– 2月收到当年度的威尼斯双年展邀请。

– 2月至5月在重庆开始创作威尼斯双年展参展作品，共完成十三幅《大家庭》组画。

– 7月应邀赴意大利参加《第46届威尼斯双年展》，展出巨幅油画三件，取名《血缘——大家庭》。其中之一后被美国著名导演奥尼弗·斯通先生收藏。

– 展览期间应邀参加在威尼斯古根海姆博物馆和格拉西宫举行的与前英国王妃戴安娜会面的晚宴会。

– 应邀赴西班牙参加巴赛罗纳现代艺术博物馆举办的《中国前卫艺术15年》，展出油画《大家庭》三幅。

– 在巴赛罗纳拜访国际大师塔匹埃斯，并参观他的工作室和艺术中心。

– 作品二幅参加德国汉堡国际前卫文化中心主办、栗宪庭主持策划的《从国家意识形态出走——中国新艺术》。

– 10月在重庆接受德国第三电视台采访。

– 作品《三个同志》被用作在巴黎举办的"秋季国际艺术节"海报。

– 作品参加在加拿大温哥华美术馆举办的《中国新艺术》展。

– 作品《母与子》被日本福冈美术馆收藏。

1996 – 移居成都玉林小区沙子堰东巷5号。

1990
Duplication of Space No.2
重复的空间2号

– 应邀赴德国参加波恩当代美术馆主办的《中国！》，展出《大家庭》组画三幅。

– 应邀出席德国外交部和文化局举办的座谈会，并接受欧州各大电视台和重要报刊的采访。

– 3月应邀赴美国参加纽约牙买加艺术中心举办的《分享的梦幻——中国当代艺术家五人展》，并接受纽约电视台专题采访。在纽约期间同时考察著名的当代艺术画廊。

– 6月应邀赴英国参加该年度的爱丁堡艺术节，作品六幅参加Fruitmarket画廊举办的《追昔——中国当代绘画》展。

– 秋季作品三幅参加澳大利亚昆士兰美术馆主办的《第二届亚太地区艺术三年展》，作品之一被昆士兰美术馆收藏。

– 作品五幅参加由巴黎法兰西廊举办的《1996来自中国的四位艺术家》。

– 参加在北京国际艺苑举办由冷林主持的《现实：今天与明天——96中国当代艺术》展。

– 12月参加北京中国美术馆，香港艺术中心举办，黄专主持的《首届当代艺术学术邀请展》，获该展的文献奖。

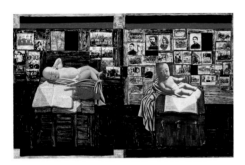

1992
Genesis
创世篇

– 在《画廊》杂志发表与黄专的对话《身份判断与文化经验》，详尽阐述自己的艺术观点及绘画方式。

1997 – 3月应邀赴香港领取由英国Coutt's国际当代艺术基金会颁发的"当代亚洲艺术新人奖"。并在港接受在港的各大报刊采访。

– 作品参加西班牙《"拱"之门大展》。

– 6月应邀赴新加坡，参加斯民艺苑举办的《红与灰——来自中国的八位前卫艺术家》及新加坡美术馆举办的《"引号"——中国当代艺术》。

– 作品《全家福》被日本冲绳美术馆收藏。

– 作品《大家庭》被香港国际会议中心收藏。

– 秋季作品12幅参加布拉格美术馆主办的《来自中国的面孔和身体——中国新艺术展》。

– 作品《姐弟》参加中国美术馆举办的《中国油画肖像艺术一百年》。

– 参加香港Schoeni画廊举办的《8+8-1——15位中国当代艺术家》共展出60幅小画。

– 六幅作品参加葡萄牙里斯本美术协会主办的《15位中国当代艺术家》。

– 作品《全家福》被荷兰Peter Stuyvesant基金会收藏，并参加该机构举办的《国际当代艺术收藏展》。

– 向四川美术院提出停职申请，并离开学校放弃教学。

– 12月应邀北京中央美院画廊举办个展，共展出作品10幅，展览取名《1997大家庭》。

– 在成都玉林西路55号投资开办"小酒馆"，由唐蕾主持。小酒馆成为一个联系各地艺术家，同时推出成都音乐的著名场所。

1998 – 在台北汉雅轩画廊举办开个展，取名《血缘：大家庭》。

– 作品5幅参加在芬兰赫尔幸基美术馆举办的《中国新艺术展》。

– 作品参加在比利时D'ostende当代美术馆举办的纪念马格利特一百年特别展《马格利特与当代艺术》。并为展览撰文《我与马格利特》。

– 作品《兄妹》被成都上河美术馆收藏，并协助该美术馆收藏和展览国内当代名家作品。

– 作品《大家庭》之一被荷兰PETER STUYVESANT基金会收藏，并参加该年度的阿姆斯特丹《国际当代艺术收藏展》。

– 参与策划在成都上河美术馆举办的《视觉的力量》。

1999 – 应邀赴法国巴黎，在法兰西画廊举办个展，共展出15件新作，展览取名《同志》。

– 栗宪庭为展览画册作序：《中国当代艺术的缩影式艺术家张晓刚和他的缩影式中国人肖像》此展为该画廊在70年代推出赵无极之后，第一次举办中国当代艺术家的个展。

– 作品二幅参加美国旧金山LIMN画廊《1999'中国当代艺术》，作品被画廊收藏。

– 作品参加在比利时Namur艺术中心举办的《面孔——国际当代艺术邀请展》。

– 作品《三个小孩》被沈阳东宇美术馆收藏，并参加该馆举办的《第一届中国当代艺术收藏展——开启的通道》。

– 作品《全家福》参加由高名潞策划，由纽约P·S·I当代艺术中心和旧金山现代美术馆联合举办《蜕变与突破——中国新艺术大展》。

– 作品收入美国出版的《世界当代艺术史》。

– 7月与妻子分居，十年婚姻宣告结束。

– 7月至9月，在昆明和大理。同时制作一些纸上水墨小品。

– 10月移居北京花家地西里116号楼。

2000 – 元月返成都参加成都现代艺术馆举办的《世纪之门——中国艺术邀请展》。参展作品之一《姐弟》被英国GASWORKS艺术基金会收藏。

– 3月应邀赴朝国参加《人+间——第三届光州国际当代艺术双年展》，共展出6幅油画。

– 作品收入英国出版的《中国艺术史》。

– 作品两幅参加美国Montclair大学美术馆举办的《超越束缚》。

– 6月应邀赴法国南方，参加佩里格市弗朗索瓦·密特朗国家文化中心举办的《中国当代肖像》。参展期间与法国著名艺术家进行交流活动，同时观摩当年度的法国里昂双年展。

– 作品《女孩肖像》被上海美术馆收藏，并参加该馆举办的《首届中国当代艺术收藏展》。

– 作品《大家庭1997》参加北京中国美术馆的《中国油画百年展》。

– 作品参加日本新汤县民会馆，宇都宫美术馆举办的《亚州当代艺术邀请展》。

– 7月至8月在成都工作室创作新作品。

– 作为代表画家收入《中国当代艺术史1989—1999》湖南美术出版社。

– 10月九幅新作在纽约Max Protech画廊举办在美国的首次个展，展览取名《张晓刚2000》。参展作品全部被收藏。

– 11月应邀赴法国参加阿密市比加底国家美术馆举办的《中国当代艺术邀展》。参展作品《同志》被该馆收藏，《兄妹》、《女孩》被瑞士收藏家丹尼尔博士收藏。

2001 – 四川美术学院体制改革，正式以待聘人员身份保留公职。

1993
Manuscript No.1
手抄本一号

– 法国巴黎法兰西画廊《是我，是我们》。

– 在北京工作室接受湖南卫视专题采访。

– 赴长沙参加湖南卫视台庆活动并进行学术交流，期间与王广义、方励均、岳敏军合作大幅作品赠送湖南卫视。

– 在北京工作室接受CNN电视台的采访。

– 作品四幅参加中国美术馆举办的《新形象——中国当代美术20年》——上海美术馆，四川美术馆，广东美术馆巡展。

– 作品二幅参加在挪威奥斯陆艺术中心举办的《"煲"——中国当代艺术展》。

– 夏天与叶永青合股创立昆明创库艺术空间。

– 作品四幅参加巴西《第三届MERCSUL双年展》。

– 10月应邀赴伦敦参加红楼轩画廊举办的《"梦"——2001中国当代艺术》，并考察英国当代艺术状况。

– 11月应邀赴韩国首尔进行学术交流。

– 12月赴成都参加成都现代艺术馆举办的《第一届成都双年展》。参展作品《吐舌头的男孩》被澳洲悉尼新南威尔斯美术馆收藏。

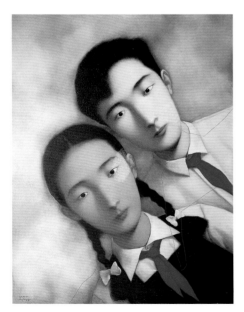

1996
Bioodline: Big Family No.3
血缘：大家庭 No.3

– 年底开始探索关于"记忆与失忆"的问题。

2002 – 四幅作品参加巴黎ENRICO NAVARRA画廊与香港汉雅轩画廊合办的《中国制造—14位中国艺术家》。

– 作品《睡婴》参加韩国首尔国家现代美术馆举办的《BABEL2002》。

– 与香港季丰轩画廊签订在法国制作版画的协议。

– 5月赴重庆，参加四川美院美术馆举办的《再看77'、78'——艺术作品的邀请展》及其关于"四川美院77'、78'现象"讨论会。同时在美院讲座《北京部份艺术家工作状态》。

– 6月赴长沙，参加长沙美伦美术馆举办的《时间的一个点·在长沙》。

– 7月开始创作图片系列《证件》。

– 8月以图片作品《证件》参与邱志杰、卢杰等策划的《长征》主题展——昆明《创库上河车间》。

– 作品参加南京博物院《中国艺术三年展》，深圳美术馆《观念的图象——2002中国当代油画邀请展》，广东美术馆《广州艺术三年展》。

– 作品参加德国杜尹斯堡《中国当代艺术展》。参加在巴黎举办的《巴黎、北京——尤伦斯藏品展》，作品被选为展览招贴。

– 9月与王广义一同赴巴黎出席非亚克博览会开幕，并监制版画的制作。

– 11月何香凝美术馆举办由黄专策划的具有历史性意义的展览《图像就是力量——王广义、张晓刚、方力钧》这一年开始创作《失忆与记忆》系列作品。

2003 – 年初在北京崔各庄建立新工作室。

– 作品参加在印度尼西亚雅加达由印度尼西亚国家画廊举办的《来自中国的艺术》展览。

– 春天，作品《失忆与记忆》参加韩国首尔、ARTSIDE画廊举办的《中国——3个面孔3种颜色》展览。

– 4月回到成都躲避非典，在成都期间写出文章《至友人的信》论述关于"失忆与记忆"的基本想法。5月到昆明继续躲避非典，并在昆明西坝永乐路创建昆明工作室。将工作室外墙涂为黑色，以此怀念北方的景色。

– 6月在法国巴黎法兰西画廊举办个展。取名《失忆与记忆》，共展出约15幅作品。

– 同时，一幅作品参加在法国巴黎非洲博物馆举办的

《东方暨白——中国绘画一百年》展览。

– 秋天回到北京，不久赴上海参加多伦现代美术馆举办的《打开的天空——当代艺术展》。

2004 – 1月携作品《女孩》赴泰国曼谷参加由顾震清策划在唐人画廊举办的《中国 现在》展览。

– 开春前往上海、参加翁玲策划的上海沪申画廊的开幕展览《超越界线》。

– 4月赴香港，由张颂仁策划在香港艺术中心举办在香港的首次个展，共展出1988－2004年间创作的五十余件作品。并由汉雅轩编辑出版个人画册，名为《时代的脐带——张晓刚绘画》。展览期间举行学术报告，讲述自己的整个心路历程及创作历史。并接受香港媒体的采访。

– 四幅《失忆与记忆》系列作品参加上海美术馆举办的《第五届上海双年展》。

– 作品参加在台湾第雅画廊举办的《面对面》展览。

– 二幅作品参加法国马塞现代艺术博物馆举办的《身体中国》展览。作品被法国著名音乐家雅尔收藏，并在其中国的演出中作为美术部分演示。

– 秋天以《失忆与记忆——一周日记》系列作品和王广义、曾浩的作品参加在上海外滩三号沪申画廊举办、由翁玲策划的《世界三》展览。

– 携作品参加在武汉、湖北美术学院美术馆举办、由美术文献杂志策划的《武汉首届美术文献提名展》，并获得文献奖。

– 开始为深圳华侨城创作巨幅油画《大家庭——地铁》。

2005 – 年初为深圳地铁开通创作的《大家庭——地铁》参加了在深圳OCAT当代艺术中心举办、由黄专策划的《起飞——OCAT当代艺术典藏展》。期间参加了学术研讨会。作品后被何香凝美术馆收藏，原将作品放在深圳地铁华侨城站的计划被推迟。

– 春节期间，在云南与朋友们一道去沅江风景写生，开始为日后的风景系列作品做准备。

– 3月导演张扬拍摄电影《向日葵》，影片里引用《大家庭》系列作品。

– 4月携四幅《失忆与记忆》系列作品，前往美国纽约参加由冷林策划在Max Protetch画廊举办的个展，并接受了当地媒体的采访。在纽约期间参观乔西画廊区，第雅美术馆、MoMA美术馆等，考察西方当代艺术及画廊

发展状态，与台湾留美艺术家进行学术交流。

– 4月底携作品赴台湾关渡美术馆参加《明日不回眸——中国当代艺术》展览。首次访台，沿台南北上至台北进行参观访问，并在日月潭停留了一天一夜。

– 6月在北京崔各庄工作室接受美国《纽约时报》专访。

– 7月回到昆明。开始尝试创作新作品系列——图片作品《书写的记忆》，后改为《描述》系列。试图用手记的方式与公共图像的资源进行并置式"描述"。

– 8月在接受中央电视台十频道人物栏目采访。

– 9月回到北京，以图片系列作品《描述》参加由黄专策划，在北京OCAT当代艺术中心举办的《柏拉图和它的七种精灵——当代艺术展》，以及学术研讨会。

– 《描述》系列图片作品参加由高世民在杭州策划的《寓言》展览。后因展览场地的问题，作品一半被毁。

– 秋天作品参加在广东美术馆举办的《广州三年展》。

– 10月初开始构思并准备新作品系列《里和外——关于社会主义新风景及家庭环境》的创作计划。同时与策划人冷林商定关于在北京公社艺术空间举办新作品个展的方案计划。

– 11月赴深圳参加由叶永青策划在深圳美术馆举办的《缘分的天空——2005中国当代架上艺术（油画）邀请展》，以及关于云南的艺术问题的学术研讨会。在深圳期间，为毛旭辉的个人画册撰写文章——《我认识的大毛》。文章中回顾了八十年代在昆明期间与大毛等朋友一起生活创作的岁月。

– 11月工作室搬到位于望京北湖渠桥旁的酒厂艺术园。并将工作室外墙涂成黄色，以此怀念云南的色彩记忆。

– 作品参加在中国美术馆举办的《大河上下——新时期中国油画回顾展》

– 两幅作品《失忆与记忆》参加韩国阿拉里奥画廊北京空间举办的中国、德国当代艺术家联展，同时也是阿拉里奥画廊的开幕展。

– 年底以作品《失忆与记忆》、《手记》两幅作品参加由范迪安等策划，在北京中华世纪坛美术馆举办的《当代视像：为收藏家办的展览——首届中国当代艺术年鉴展》。

2006 – 元月回到昆明，开始创作新系列作品——《里和外——关于社会主义新风景及家庭环境》。

– 4月中，由冷林策划在北京公社艺术空间举办新作品个展，展览取名为《Home》。共展出油画作品《里和外》12幅，图片作品系列《描述——英雄儿女》10幅。

– 黄专再次在深圳策划《柏拉图和它的七种精灵》。展览设在OCT当代艺术中心，以二十幅图片作品参展。之后，作品参加由黄专策划，在纽约举办的中国艺术家联展《江湖——中国当代艺术欧美巡展》。

– 图片作品《描述》参加由巫鸿策划，在纽约华美协进社美术馆举办的《中国当代艺术中的书籍再创》展。

– 4月下旬赴重庆，于四川美术学院建立张晓刚艺术工作室，以此鼓励年轻艺术家进行创作。

– 5月初，前往韩国监制版画作品的制作。期间接受了韩国媒体的采访。

– 6月前往深圳参加何香凝美术馆收藏的作品《大家庭——地铁》正式悬挂于深圳市地铁华侨城站的开幕仪式。

– 7月初接受日本多家电视台及报刊杂志的专访。在日本东京Wonder Site Shibuya艺术中心举办在日本的首次个展，展览名为《张晓刚》

– 7月底，陪伴女儿去泰国度假，同时创作纸上油画作品。

– 8月至9月期间连续接受美国、法国等媒体及个人专访。

– 为香港亚洲艺术文献库的发展捐赠油画作品《女孩》。

– 入秋，以《失忆与记忆》和《大家庭》系列油画作品参加由冯博一策划的在维也纳Sammlung Essl美术馆举办的《中国——中国当代艺术的转世魅影》展。

– 10月，作品《父女》参加中国美术馆与台北市立美术馆合作《展开的现实主义-1978年以来的中国大陆油画》。

– 11月，前往韩国首尔ARTSIDE画廊举办在韩国的首次个展。共展出油画作品四幅，纸上作品七幅及版画。展览期间接受韩国各大媒体采访。

– 为了2007年的个展，开始思考新的作品——雕塑系列作品。

– 12月25日，在上海的一间酒吧与佳佳订婚，曾浩、陈嫣也同时订婚。

– 年底接受了英国，法国，等各地媒体的采访。

2007 – 1月12与佳佳在深圳结婚。

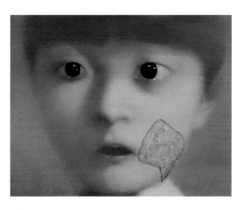

2000
My Daughter
我的女儿

回到北京开始制作雕塑作品的模型。

– 1月版画作品参加成都K画廊开幕展《新西南当代绘画展》。

– 2月女儿放假来到北京，随后一起回到昆明度假。参加由程忻东策划在俄罗斯国立特列恰科夫美术馆举办的《中国当代社会艺术展》。

– 3月，参加上海现在画廊开幕展《上海·现在》。纸上作品参加，南京四方美术馆《纸上谈兵》。

– 4月作品参加贵阳双年展，并赴俄罗斯首都莫斯科出席《中国社会艺术》展的开幕式。

– 参加广东美术馆《从西南出发》。

– 与纽约Pace画廊商谈合作事宜。

– 7月，作品《全家福》参加高岭策划在北京今日美术馆举办的《黑白灰——一种主动的文化选择》。

– CNN在《谈论亚洲》节目中播出了摄于北京酒厂工作室的访谈，同月于京接受杨澜访谈。

– 8月回到云南的家，创作了两套描述系列的图片作品。

– 9月，个展《张晓刚》在芬兰坦佩雷的萨拉希尔顿开幕。同月，作品《情人》参加中国美术馆策划在俄罗斯圣彼得堡俄罗斯国家美术馆举办的《开放的中国艺术》。

– 开始制作版画。

– 10月应美国伊利诺伊大学艺术系教授乔纳森之邀，赴美国伊利诺伊大学举办讲座《Personal History》。

– 10月十四幅图片作品《描述2007》参加中国美术馆

与奥地利维也纳当代艺术博物馆主办《中国-面向现实》，并出席展览开幕式。

– 11月80年作品《幽灵》和《遗梦集》等参加尤伦斯当代艺术基金会北京艺术中心开幕展"85新潮：中国第一次当代艺术运动"，并于11月24日在尤伦斯基金会举办讲座。

– 为香港亚洲艺术文献库的发展捐赠版画作品《七彩天安门》。

– 11月底何各庄新工作室落成，并将工作室迁至新址。

– 12月10日与王广义、方力钧、岳敏君在重庆坦克库的冠名工作室正式启动，并于三位艺术家一起受聘四川美术学院特聘教授。

2008 – 1月2日接受新加波亚洲新闻台采访，并开始构思创作《修正》系列之一《关于睡眠》。

– 2月与布拉格美术馆馆长Nedoma和策展人张颂仁商谈9月布拉格展览事宜，并开始着手创作新作《绿墙》系列。

– 3月接受英国《卫报》，日本《朝日新闻采访》。

– 5月12日四川汶川发生8.0级地震。
为地震灾区创作油画《父亲与女儿》，参加吕澎、周春芽组织的义拍，并将义拍所得全部捐献给中国红十字会，用于灾区的救援和灾后重建。

– 5月接受加拿大国家电台及西班牙《Architectural Digest Espana》杂志采访。

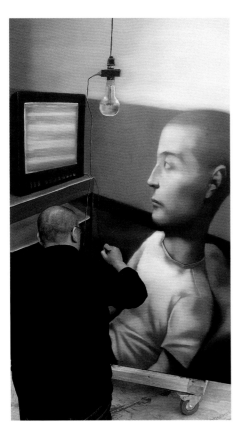

2008 working at Hegezhuang studio in Beijing
2008年，于何各庄工作室，创作中

Exhibition History
艺术简历

Solo Exhibitions

2008

"Revision", PaceWildenstein, New York, U.S.A.

2007

"Zhang Xiaogang", Sara Hilden Art Museum, Tampere, Finland

2006

"Home – Zhang Xiaogang", Beijing Commune, Beijing, China

"Zhang Xiaogang Exhibition", The Art Centre of Tokyo, Japan

"Amnesia and Memory", Artside Gallery, Souel, Korea

2005

"Zhang Xiaogang 2005", Max Protetch Gallery, New York, U.S.A.

2004

"Umbilical Cord of History: Paintings by Zhang Xiaogang", Hong Kong Art Center, Hong Kong

2003

"Amnesia and Memory", Gallery of France, Paris, France

2000

"Zhang Xiaogang 2000", Max Protetch Gallery, New York, U.S.A.

1999

"Les Camarades", Gallery of France, Paris, France

1998

"Bloodline: The Big Family 1998", Hanart Gallery, Taipei

1997

"Bloodline: The Big Family 1997", Gallery of the Central Academy of Fine Arts, Beijing, China

1989

"Lost Dreams", Gallery of the Sichuan Academy of Fine Arts, Chongqing, China

Selected Group Exhibitions

2008

"Waiting on the Wall: Chinese New Realism and Avant-Garde in Eighties and Nineties, Groningen Museum, Groningen, The Netherlands

"Case Studies of Artists in Art History and Art Criticism", SZ Art Center, Beijing, China

"Our Future: The Guy & Myriam Ullens Foundation Collection", Ullens Center for Contemporary Art, Beijing, China

"Avant-Garde China: Twenty Years of Chinese Contemporary Art", Roppongi, Minato-ku, Tokyo, Japan

"Facing the Reality: Chinese Contemporary Art", National Art Museum of China, Beijing, China

2007

"China – Facing Reality", Museum Moderner Kunst Stiftung Ludwig, Vienna, Austria

"From Southeast", Guangdong Museum of Fine Art, Guangzhou, China

"From New Figurative Image to New Painting", Tang Contemporary Art, Beijing, China

"Black White Gray – A Conscious Cultural Stance", Today Art Museum, Beijing, China

"85 New Wave: The Birth of Chinese Contemporary Art", Ullens Center for Contemporary Art, Beijing, China

2006

"The Blossoming of Realism – The Oil Painting from Mainland China since 1978", Taipei Fine Arts Museum, Taipei

"China Now: Fascination of a Changing World", SAMMLUNG ESSL Museum, Vienna, Austria

"Reinventing Books in Chinese Contemporary Art", China Institute, New York, U.S.A.

"Jiang Hu – Chinese Contemporary Art European and American Traveling Exhibition", Tilton Gallery, New York, U.S.A.

"Food and Desire", South Silk Restaurant, Beijing, China

"Plato and His Seven Spirits", OCT Contemporary Art Center, Shenzhen, China

2005

The 2nd Guangzhou Triennial", Guangdong Museum of Art, Guangzhou, China

"Take Off – An Exhibition of the Contemporary Art Collection in the He Xiangning Art Museum and Contemporary Art Terminal", He Xiangning Art Museum, OCT Contemporary Art Terminal, Shenzhen, China

"Plato and His Seven Spirits", OCT Contemporary Art Center, Shenzhen, China

"Always to the Front – Chinese Contemporary Art", Kuandu Museum of Fine Arts, Taipei

"Mahjong: Contemporary Chinese Art from the Sigg Collection", Kunst Museum Bern, Bern, Switzerland; Hanburger Kunsthalle, Hamburg, Germany

"Contemporary View Exhibition for Collector: China First Contemporary Art Almanac Exhibition", Millennium Museum of Art, Beijing, China

"2005 Invitational Exhibition of China Contemporary Oil Painting", Shenzhen Art Museum, Shenzhen, China

"Big River – New Period of Chinese Oil Painting and Retrospective Exhibition", National Art Museum of China, Beijing, China

"Allegory", Hangzhou, China

2004

The 5th Shanghai Biennial, Shanghai Art Muse um, Shanghai, China

"China, the body everywhere?", Museum of Contemporary Art, Marseilles, France

"Face to Face", Accor Gallery, Taiwan

"Beyond Boundaries", Shanghai Gallery of Art, Shanghai, China

"China Now", Tang Gallery, Bangkok, Thailand

"The 1st Wuhan Fine Arts Archive Nomination", Art Gallery, Hubei Academy of Fine Arts, Wuhan, China

"Three Worlds", Shanghai Gallery of Art, Shanghai, China

2003

"From China with Art", Indonesian National Gallery, Jakarta, Indonesian

"3Face 3Colors", Artside Gallery, Seoul, Korea

"Open Sky – Contemporary Art Exhibition", Shanghai Duolun Museum of Modern Art, Shanghai, China

"The East Daybreak: 100 Years of Chinese Painting", Africa Museum, Paris, France

2002

"A Point in Time", Changsha Meilun Museum of Art, Changsha, China

"14 Chinese Artists / Made in China", Enrico Navarra Gallery, Paris, France

BABEL 2002, National Museum of Contemporary Art, Korea

The 1st Triennial of Chinese Art, Guangdong Museum of Fine Arts, Guangzhou, China

"Review 77', 78'", Gallery of Sichuan Academy of Fine Arts, Chongqing, China

"Long March", Upriver Loft, Kunming, China

"The Image of Concept", Shenzhen Art Museum, Shenzhen, China

"In Memory: The Art of After War", Sidney Mishkin Gallery, New York, U.S.A.

"East + West – Contemporary Art of China", Kunstlerhaus, Vienna, Austria

"Image is Power", He Xiangning Art Museum, Shenzhen, China

2001

"Towards A New Image: Twenty Years of Contemporary Chinese Art", National Art Museum of China, Beijing; Shanghai Art Museum, Shanghai; Sichuan Art Museum, Chengdu; Guangdong Art Museum, Guangzhou, China

The 1st Chengdu Biennial, Chengdu Contemporary Art Museum, Chengdu, China

"Dream – 2001 Contemporary Chinese Art Exhibition", The Red Mansion, London, U.K.

"Hot Pot", Artist Center of Oslo, Norway

"It's me, It's us", Gallery of France, Paris, France

The 3rd Mercosul Biennial, Porto Alegre, Brazil

2000

"Man+SPACE: Kwangju Biennale 2000", Kwangju, Korea

"Transcending Boundaries", Montclair State University, New Jersey, U.S.A.

"The First Collection Exhibition of Chinese Contemporary Art", Shanghai Art Museum, Shanghai, China

"Hundred Years of Chinese Oil Painting", National Art Museum of China, Beijing, China

"Portraits De China Contemporaine", Espace Culturel Francois Mitterrand, Perigueux, France

"Contemporary Art of China", Picardie Museum, Amiens, France

1999

"1999 Art China", LIMN Gallery, San Francisco, U.S.A.

"Faces: Entre Portrait et Anonymat", Maison de la Culture Namur, Belgium

"New Modernism for a New Millennium: Works by Contemporary Asian Artists from the Logan Collection", Museum of Modern Art and LIMN Gallery, San Francisco, U.S.A.

"The Collections of Dongyu Art Museum", Dongyu Art Museum, Shenyang, China

"Inside Out: New Chinese Art", Asia Society and P.S.1 Contemporary Art Center, New York; San Francisco Museum of Modern Art, San Francisco, U.S.A.

1998

"China New Art", Helsinki Art Museum, Helsinki, Finland

"Exhibition of International Contemporary Art Collection", Amsterdam, The Netherlands; Brussels, Belgium

"Exhibition of Collection of Shenghe Gallery", Chengdu, China

1997

"China New Art", Lisbon Museum of Art, Portugal

"Faces and Bodies from Middle Kingdom: Chinese Art of the 90s", Prague Art Museum, Prague, Czech Republic

"8+8-1: 15 Chinese Artists", Schoeni Art Gallery, Hong Kong

"Red and Grey: Eight Avant-Garde Chinese Artists", Soobin Art Gallery, Singapore

"Hundred Years of Chinese Portrait", National Art Museum of China, Beijing, China

"Quotation Marks: Chinese Contemporary Paintings", Modern Art Museum, Singapore

1996

"Reckoning with the Past: Contemporary Chinese Paintings", Fruitmarket Gallery, Edinburgh, U.K.

The 1st Academic Exhibition of Chinese Contemporary Art, National Art Museum of China, Beijing; Hong Kong Art Center, Hong Kong, China

2nd Asia Pacific Triennial of Contemporary Art, Queensland Art Museum, Australia

1995

The 46th Venice Biennial, Venice, Italy

"China New Arts", Vancouver Art Museum, Vancouver, Canada

"Chinese Contemporary Art", Hamburg, Germany

1994

Chinese Contemporary Art at Sao Paulo – 22nd International Biennial of Sao Paulo, Brazil

1993

"Chinese New Art from Post-1989", Hong Kong Art Center, Hong Kong

"Mao Goes Pop – China Post-89", Museum of Contemporary Art, Sydney, Australia

"Chinese Fine Arts in 1990's: Experiences in Fine Arts of China", Sichuan Art Gallery, Chengdu, China

1992

"The Guangzhou Biennial: Oil Paintings from the 90's", Guangzhou, China

"Documentary Exhibition of Chinese Contemporary Art", Beijing, Guangzhou, Chongqing, Shenyang, Shanghai and Nanjing, China

1991

"I Don't Want to Play Cards with Cézanne", Pacific Asia Museum, California, U.S.A.

1989

"China Avant-Garde", National Art Museum of China, Beijing, China

Collections

1988

"Art from Southeast of China", Chengdu, China

1987

"Modern Art of China", National Art Museum of China, Beijing, China

1985

"Neo-Realism", Shanghai and Nanjing, China

Upriver Gallery, Chengdu, China

Dongyu Museum of Fine Arts, Shenyang, China

Shanghai Art Museum, China

Shenzhen Art Museum, China

Shenzhen He Xiangning Art Museum, China

Shenzhen OCT Contemporary Art Terminal, China

Hubei Academy of Fine Arts, China

Hong Kong International Conference & Exhibition, China

Fukuoka Museum of Art, Japan

Okinawa Museum of Art, Japan

National Museum of Contemporary Art, Korea

Guggenheim Museum of Art, U.S.A.

Asia & Pacific Art Museum, U.S.A.

Logan Collection-San Francisco Museum of Modern Art, U.S.A.

Coutt's Art Foundation, England

Gasworks Art Foundation, England

Peter Stuyvesant Art Foundation, The Netherlands

Queensland Art Museum, Australia

National Gallery of Australia, Australia

The Art Gallery of New South Wales, Sydney, Australia

Picardie National Museum Amiens, France

Saint-denis Art Museum, Paris, France

个 展

2008

"修正", 佩斯维尔登斯坦画廊, 纽约, 美国

2007

"张晓刚", 萨拉·希尔顿美术馆, 坦佩雷, 芬兰

2006

"Home——张晓刚", 北京公社, 北京, 中国

"张晓刚展", 东京艺术中心, 东京, 日本

"失忆与记忆, ARTSIDE画廊, 首尔, 韩国

2005

"张晓刚2005", Max Protetch画廊, 纽约, 美国

2004

"时代的脐带——张晓刚绘画", 香港艺术中心, 香港

2003

"失忆与记忆", 法兰西画廊, 巴黎, 法国

2000

"张晓刚2000", Max Protetch画廊, 纽约, 美国

1999

"同志", 法兰西画廊, 巴黎, 法国

1998

"血缘：大家庭1998", 汉雅轩画廊, 台北

1997

"血缘：大家庭1997", 中央美院画廊, 北京, 中国

1989

"遗梦集", 四川美术学院陈列馆, 重庆, 中国

群 展

2008

"个案——艺术史和艺术批评中的艺术家", 圣之空间, 北京, 中国

"我们的未来——尤伦斯基金会收藏展", 尤伦斯当代艺术中心, 北京, 中国

"前卫中国：中国当代美术20年", 日本国立新美术馆, 东京；日本国立国际美术馆, 大阪, 日本

"写在墙上：中国二十世纪八九十年代新现实主义与前卫艺术展", 格罗宁根美术馆, 荷兰

"面向现实", 中国美术馆, 北京, 中国

2007

"中国——面向现实", 维也纳当代艺术博物馆, 维也纳, 奥地利

"中国当代社会艺术", 国立特列恰科夫美术馆, 俄罗斯

"从西南出发", 广东美术馆, 广州, 中国

"从新具象到新绘画", 唐人画廊, 北京, 中国

"黑白灰——一种主动的文化选择", 今日美术馆, 北京, 中国

"85'新潮——中国第一次当代艺术运动", 尤伦斯当代艺术中心, 北京, 中国

2006

"展开的现实主义——1978年以来的中国大陆油画", 台北市立美术馆, 台北

"中国当代艺术中的书籍再创", 华美协进社, 纽约, 美国

"江湖——中国当代艺术欧美巡展", Tilton画廊, 纽约, 美国

"食欲展", 茶马古道, 北京, 中国

"今日中国——中国当代艺术的转世魅影", 埃斯尔美术馆, 维也纳、奥地利

2005

"广州三年展", 广东美术馆, 广州, 中国

"起飞——OCAT当代艺术典藏展", OCAT当代艺术中心, 深圳, 中国

"明日不回眸——中国当代艺术", 关渡美术馆, 台湾

"柏拉图和它的七种精灵——当代艺术展", OCAT当代艺术中心, 深圳, 中国

"麻将——希克中国当代艺术收藏展", 伯恩美术馆, 瑞士；菲利普奥托格基金会, 汉堡, 德国

"当代视像：为收藏家办的展览——首届中国当代艺术年鉴展", 中华世纪坛美术馆, 北京, 中国

"缘分的天空——2005中国当代架上艺术（油画）邀请展", 深圳美术馆, 深圳中国

"大河上下——新时期中国油画回顾展", 中国美术馆, 北京, 中国

"寓言", 杭州, 中国

"第五届上海双年展", 上海美术馆, 上海, 中国

"面对面——六位艺术家一个时代", 第雅画廊, 台湾

"超越界线", 沪申画廊, 上海, 中国

"中国 现在", 唐人画廊, 曼谷, 泰国

"武汉首届美术文献提名展", 武汉, 湖北美术学院美术馆中国

"世界三", 沪申画廊, 上海, 中国

"身体中国", 马塞现代艺术博物馆, 马塞, 法国

2003

"来自中国的艺术", 印度尼西亚国家画廊, 雅加达, 印度尼西亚

"中国——3个面孔3种颜色", ARTSIDE画廊, 首尔, 韩国

"打开天空——当代艺术展", 多伦现代美术馆, 上海、中国

"东方暨白——中国绘画一百年", 非洲博物馆, 巴黎, 法国

2002

"时间的一个点·在长沙", 美仑美术馆, 长沙, 中国

"14位中国艺术家——中国制造", Enrico Navarra画廊, 巴黎, 法国

"BABEL 2002", 国家现代艺术馆, 韩国

"再看77'、78'艺术作品邀请展"中国、重庆四川美术学院美术馆

"长征"上河创库车间, 昆明, 中国

"巴黎·北京收藏展", 巴黎, 法国

"首届中国艺术三年展", 广州美术馆, 广州, 中国

"图象就是力量", 何香凝美术馆, 深圳, 中国

"观念的图像——2002中国当代油画邀请展", 深圳美术馆, 深圳, 中国

"记忆——战后的艺术", Sidney Mishkin 画廊, 纽约, 美国

"东加西——中国当代艺术展", 艺术家之家, 维也纳, 奥地利

"第一届成都双年展", 现代艺术馆, 成都, 中国

"梦——2001中国当代艺术", 红楼基金会, 伦敦, 英国

"新形象——中国当代美术二十年", 中国美术馆, 北京, 中国

"是我, 是我们", 法兰西画廊, 巴黎, 法国

"煲——中国当代艺术展", 奥斯陆艺术家中心, 挪威

"第三届MERCOSUL双年展", 巴西

2000

"人+间——第三届光州国际当代艺术双年展", 光州, 韩国

"超越束缚", 蒙特克莱尔大学美术馆, 新泽西, 美国

"中国当代肖像", 弗郎索瓦·密特朗国家文化中心, Perigueux, 法国

"首届中国当代艺术收藏展", 上海美术馆, 中国

"中国油画百年展", 中国美术馆, 北京, 中国

1999

"中国当代艺术", LIMN 画廊, 旧金山, 美国

"面孔——国际当代艺术展", 纳幕尔艺术中心, 比利时

"第一届中国当代艺术收藏展", 东宇美术馆, 沈阳, 中国

"蜕变与突破：中国新艺术", 纽约PS1当代艺术中心, 旧金山现代美术馆, 美国

1998

"中国新艺术", 赫尔辛基美术馆, 赫尔辛基, 芬兰

"国际当代艺术收藏展", 阿姆斯特丹, 荷兰

"首届中国当代艺术收藏展", 上河美术馆, 成都, 中国

1997

"中国新艺术", 里斯本美术馆, 葡萄牙

"来自中国的面孔和身体——中国新艺术", 布拉格美术馆, 布拉格, 捷克

"8+8-1——15位中国当代艺术家", Schoeni画廊, 香港

"引号——中国当代艺术新加坡", 新加坡美术馆, 新加坡

"红与灰——来自中国的八位前卫艺术家", 斯民艺苑, 新加坡

"中国油画肖像艺术一百年", 中国美术馆, 北京, 中国

1996

"中国！", 波恩当代艺术博物馆, 德国

"追昔——中国当代绘画", 水果市画廊, 爱丁堡, 英国

"第二届亚太地区当代美术三年展", 昆士兰美术馆, 昆士兰, 澳大利亚

"1996来自中国的四位当代艺术家", 法兰西画廊, 巴黎, 法国

"现实：今天与明天——96中国当代艺术", 国际艺苑中国, 北京, 中国

"首届当代艺术学术邀请展", 中国美术馆, 北京；香港艺术中心, 香港, 中国

1995

"第46届威尼斯双年展", 威尼斯, 意大利

"中国前卫艺术15年", 巴塞罗那现代艺术博物馆, 巴塞罗那, 西班牙

"中国新艺术", 温哥华美术馆, 温哥华, 加拿大

"从国家意识形态走出——中国新艺术", 汉堡国际前卫文化中心, 汉堡, 德国

1994

"第22届圣保罗双年展", 圣保罗, 巴西

1993

"后89中国新艺术大展", 香港艺术中心, 香港；马博罗画廊, 伦敦, 英国

"'毛'走向'波普'", 悉尼当代美术馆, 悉尼, 澳大利亚

"九十年代中国美术——中国经验", 成都, 中国

1992

"九十年代中国美术〈油画〉双年展", 广州, 中国

"中国当代艺术文献资料展", 北京、广州、重庆、沈阳、上海、南京等地巡展, 中国

1991

"不与塞尚玩牌——中国前卫艺术展美国", 加洲亚太艺术博物馆,

加利福尼亚, 美国

1989

"中国现代艺术大展中国", 中国美术馆, 北京, 中国

1988

"来自西南的艺术", 成都, 中国

1987

"中国现代油画", 中国美术馆, 北京, 中国

1985

"新现实主义油画", 上海, 南京, 中国

主要收藏

中国上海美术馆

中国深圳美术馆

中国深圳何香凝美术馆

中国深圳OCT当代艺术中心

香港国际会展中心

韩国汉城国家现代艺术馆

日本福冈美术馆

日本冲绳美术馆

美国古根海姆美术馆

美国亚太艺术博物馆

美国旧金山现代艺术馆

澳洲昆士兰美术馆

澳洲国家美术馆

澳大利亚悉尼新南威而士美术馆

法国巴黎圣德尼美术馆

英国 Gasworks艺术基金会

英国 库兹艺术基金会

阿姆斯特丹Peter Stuyvesant艺术基金会

法国阿密市比加底国家美术馆